ESRI Press

REDLANDS, CALIFORNIA

Children Map the World
Volume 2

Children Map the World

Selections from the Barbara Petchenik
Children's World Map Competition

Temenoujka Bandrova, Jesus Reyes Nunez, Milan Konecny, and Jeet Atwal, editors

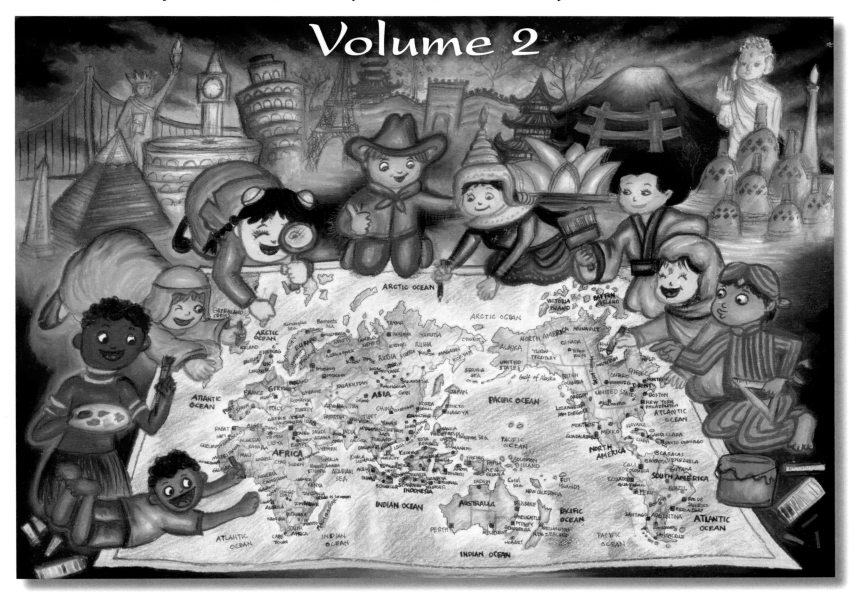

Volume 2

ESRI PRESS
REDLANDS, CALIFORNIA

ESRI Press, 380 New York Street, Redlands, California 92373-8100

Copyright © 2010 International Cartographic Association

All rights reserved. First edition 2010

14 13 12 11 10 1 2 3 4 5 6 7 8 9 10

Printed in the United States of America

Library of Congress Cataloging-in-Publication Data

Barbara Petchenik Children's World Map Competition. Selections

Children Map the World : selections from the Barbara Petchenik Children's World Map Competition / Jacqueline M. Anderson ... [et al.], editors.—1st ed.

 p. cm.

 ISBN 1-58948-125-9 (pbk. : alk. paper)

 1. Map drawing—Competitions—Juvenile literature. I. Anderson, Jacqueline Margaret. II. Title.

GA130B23 2005

912—dc22 2005007658

Ask for ESRI Press titles at your local bookstore or order by calling 800-447-9778. You can also shop online at www.esri.com/esripress. Outside the United States, contact your local ESRI distributor.

ESRI Press titles are distributed to the trade by the following:

In North America:

Ingram Publisher Services

Toll-free telephone: 800-648-3104

Toll-free fax: 800-838-1149

E-mail: customerservice@ingrampublisherservices.com

Cover map:
Many Nations, One World
Nicholas William
Age 15
Indonesia
SMA St. Bellarminus, Menteng, Jakarta Pusat
2005

Cover design	Jennifer Hasselbeck
Interior design	Donna Celso
Editing	Tiffany Wilkerson
Cartography	Riley Peake
Print production	Cliff Crabbe and Lilia Arias

The editors and publisher would like to thank the young cartographers whose work appears in this book.

Many Nations — One World

Temenoujka Bandrova, Jesus Reyes Nunez, Milan Konecny, and Jeet Atwal

Today's children are growing up in an age when the Internet, improved transportation, migration, and globalization are opening more windows to the world than ever before. It isn't out of the ordinary for children of today to travel to distant places on a family vacation; to Web chat with a friend thousands of miles away; or to move to a different city, state, or even country! As our youth become more interested and informed about happenings half a block or half the world away, education in spatial skills such as map reading and analysis becomes essential. The International Cartographic Association (ICA), as the world authoritative body for cartography, provides support to help meet that need.

The ICA was founded on June 9, 1959, in Bern, Switzerland, with the mission of promoting the discipline and profession of cartography: the conception, production, dissemination, and study of maps. At present, the range of scientific, technical, and social research is reflected by the work of its twenty-two commissions and eight working groups lead by people all over the world.

The ICA Commission on Cartography and Children—created by Jacqueline Anderson (Concordia University, Montreal, Canada) and other colleagues from different continents—was formed to introduce the power of maps to children. Its goals are to promote the use and enjoyment of maps by children, increase understanding of how children engage maps, and raise the standard of maps and atlases produced for children. One of the most important ways the commission reaches out to children is through its roles in rule creation and judging for the Barbara Petchenik Children's World Map Competition, an international competition organized every two years with the participation of ICA member countries.

The Barbara Petchenik Children's World Map Competition

Barbara Bartz Petchenik (see "A biographical note" on page 115) was the first woman to attain the office of vice president of the International Cartographic Association (ICA). During her accomplished life, she contributed significantly to the development of cartographical research on maps for children. To honor her efforts, the ICA organized a biannual international map competition for children in 1993, and continues to host it to this day. Over the years, the number of countries participating has grown continually. In 2007, thirty-six countries submitted entries, and the total number of finalists since the competition's inception is close to one thousand. The ICA is the only international and professional association that organizes a map competition for children on a regular basis.

The goal of the contest is to promote the creative representation of the world in graphic form by children. Children fifteen years old and younger are encouraged to draw a map on a general theme that is changed every four years. Examples of these themes include "Save Our Environment," "Many Nations—One World," and "Living in a Globalized World."

The competition is divided into two levels. The first level is a national competition organized by coordinators who reach out to schools, local media, and online communities for submissions. From these submissions, six (formerly five) winners are selected to represent their countries at the second level, the international competition. All finalists from the international competition are sent to Carleton University Library in Ottawa, Canada, where they are archived and made available for viewing on the Web.

This book is a collection of one hundred maps, representing thirty-seven countries, submitted under the theme "Many Nations—One World." These maps were selected from the international portions of the Barbara Petchenik Children's World Map Competition in 2005 (A Coruna, Spain) and 2007 (Moscow, Russia). For more information about the competition and the map archive at Carleton University Library, see "Resources" on page 123.

Many Nations—One World

Themes are chosen for the competitions to give participants a starting point for the message of their maps. Instead of a simple drawing of the globe, each map should represent the theme of the competition both graphically and through its title. This method requires the participants to consider how best to transmit their message visually and to understand at least one map element—the title.

Organizers choose themes that will provoke children to think about their national identity and its place within the world community. "Many Nations—One World" is a theme that asks children to consider children from different countries, from different ethnic groups or minorities, and from different religious backgrounds. This consideration is manifested in their drawings and reflected in their map titles:

- A Map of the World in Colors for Dancing (page 6)
- All Together for a Common World (page 11)
- Happy Together, the Global Family (page 23)
- Let's Make Our World Merrier with Smiles of United Nations (page 40)

Having a theme also helps young mapmakers understand that a map should have special contents and elements, such as continents, oceans, rivers, and mountains.

How children map the world

The Barbara Petchenik Children's World Map Competition offers educators, cartographers, and amateur map enthusiasts a wonderful opportunity to analyze how children apply spatial thinking and approach mapping. Submissions to the competition provide a wide spectrum of categories of classification based on the solutions used to draw the "basemap" or represent thematic information (in this case, the message of the competition). A map can belong to two or more categories and subcategories; there are no rigid boundaries between them. For example, children can represent a theme with a positive or negative message, realistic or fantastic depictions of land, or a humorous scene to represent their ideas.

Applying this type of analysis to the selections in this volume, one might notice that the maps can be categorized based on the size of the represented territory: the whole earth can be drawn as seen from space ("Use Less Plastic Bags" on page 9), or maybe only a few regions or continents are represented ("Fixing the World, Together" on page 98).

These maps can also be categorized by the kind of cartographic projection used to represent the earth. In some cases, younger children do not use any traditional projection to make their maps ("This Is My World!" on page 18). Some children copy frequently used projections from atlases found at their school ("Peace All Over the World" on page 58). A special group within this category represent territories in unusual ways, such as with human shapes ("A Lot of Countries in One World" on page 7), animal shapes ("Many Cows, One Milk" on page 50), botanical shapes ("Planet without Colors is Not a Planet" on page 70), or human-made shapes such as buses ("Many Nations, One World" on page 51).

The thematic illustrations of a map can also be analyzed and classified. Young cartographers may use illustrations to evoke humanity's relationship with the world ("One World, Remember a World of PANGEA" on page 102, "Tsunami-2004" on page 105); they may portray animals ("United Nations, a Peace World" on page 91), or nature ("Nurture Mother Earth and Watch Her Bloom" on page 27), or concepts created by society ("Make It Possible" on page 78).

One of the easiest ways to analyze and classify these maps is by the medium used to create them: pencil; pen; paint; photo montage (Monique Rossouw's untitled map on page 109); natural materials such as beans, flowers, and leaves; or artificial materials such as paper, plastic, or textile ("We Have Different Colors of Skin, but We Are All Children" on page 83). Children also use different technologies to

make their maps. During the first twelve years of the competition, map submissions were predominantly drawn or painted; but recently the number of maps made using digital techniques (or a combination of digital and hand-drawn techniques) has increased. A very nice example is "Surpassing Countries" on page 90.

As the previous examples demonstrate, submissions to the Barbara Petchenik Children's World Map Competition are a wonderful source of information on how children engage and experience maps. In the past, submissions from the competition have been used to analyze children's understanding of map elements and map creation, improve maps created for children, and develop ideas for children's atlases.

Future of the competition

In an effort to improve the Barbara Petchenik Children's World Map Competition, organizers introduced changes during the Twenty-fourth International Cartographic Conference in 2009. The competition inaugurated a new system of evaluation and increased the number of drawings that can be sent by every participating nation to the international competition to six. In addition, the theme for the 2009 and 2011 competitions was selected: "Living in a Globalized World."

The ICA expects more and more nations will participate in the competition in the future, and that the quality and message of the submissions will continue to delight and surprise. Members of the ICA hope that the increased interest in the competition will yield a new generation of mapmakers and map users; youngsters with a greater understanding of the world around them and their place in it.

Age 4-9

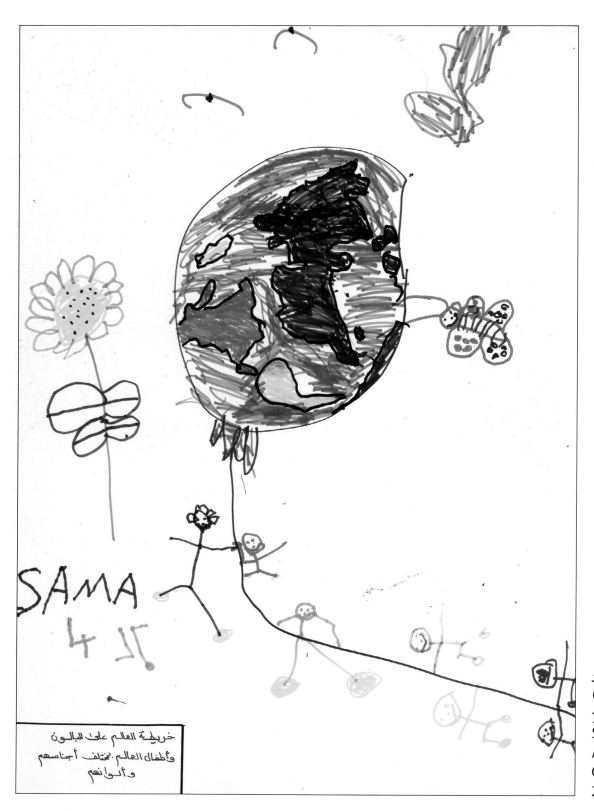

All the World in a Balloon
(Special mention,
youngest participant)
Sama Salah Al Sayed
Age 4
Qatar
2007

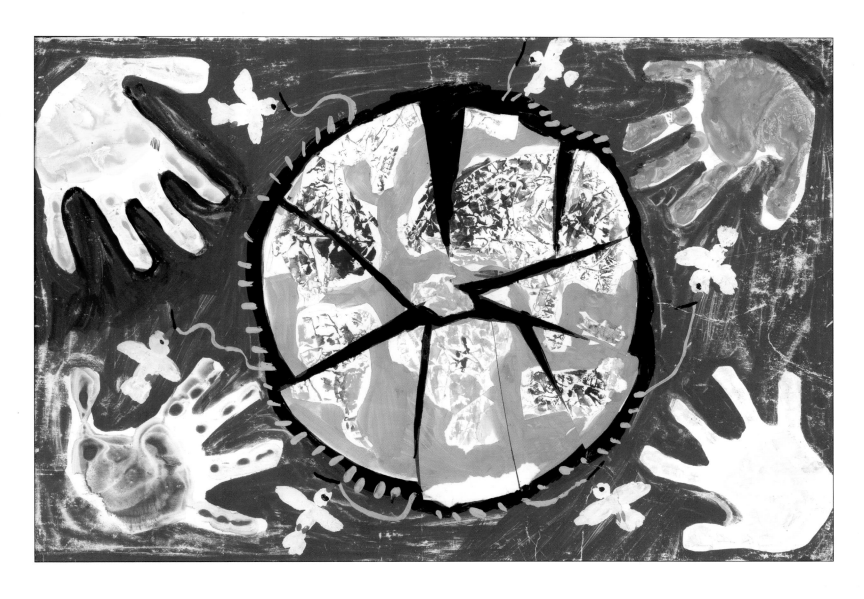

Earth Future—In Our Hands
Dasha Kolomys
Age 5
Ukraine
Nursery School No. 47, Rivne
2007

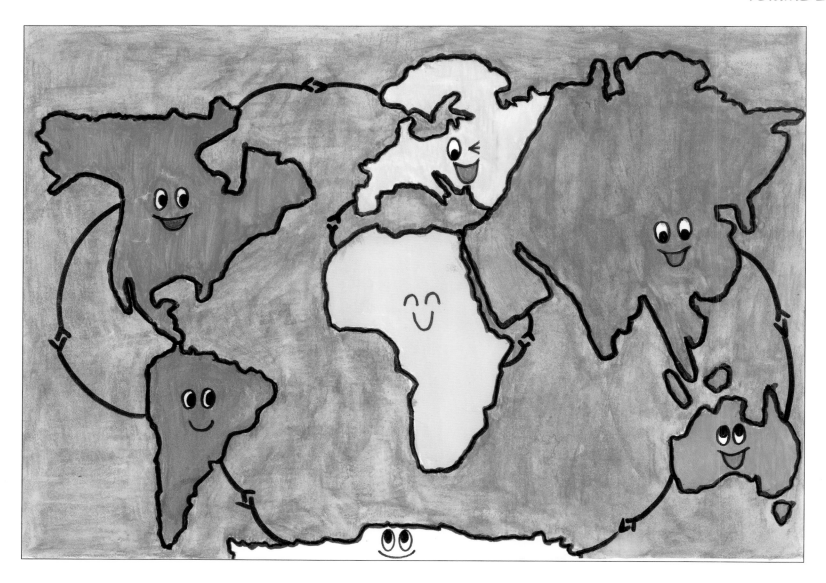

Friendship Forever
Michelle Yang
Age 5
China
St. Johannes College, Hong Kong
2005

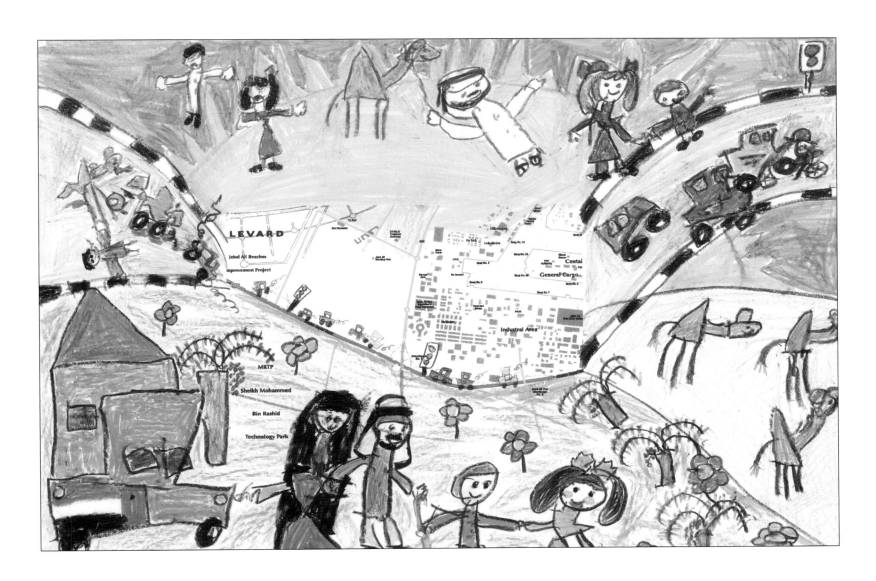

Untitled
Maryam Rashid Harib
Age 5
United Arab Emirates
Alghad Kindergarten, Al Ain
2007

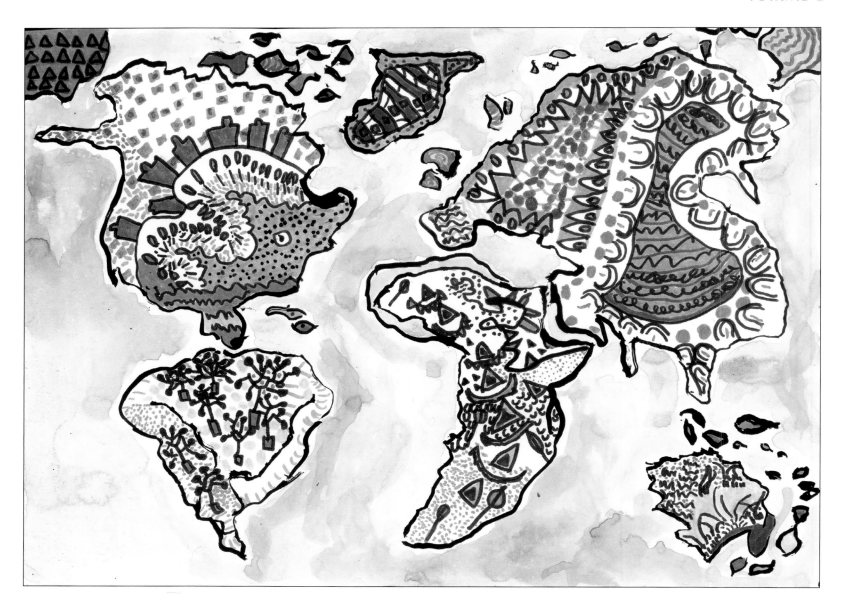

A Map of the World in Colors for Dancing
Elvis Plantak
Age 6
Croatia
Kindergarten "Dješji svijet," Varaždin
2007

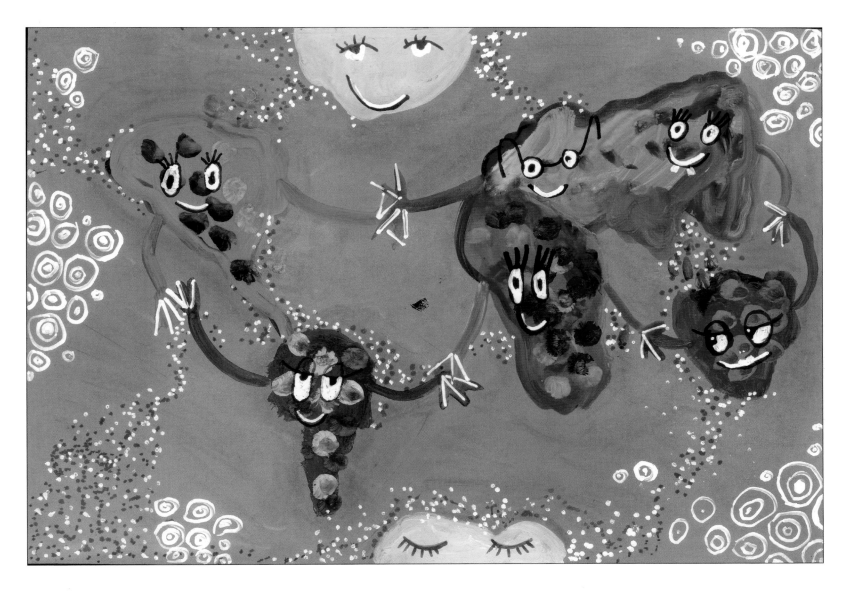

A Lot of Countries in One World (Public award)
Lukas Kareiva
Age 7
Lithuania
Dariaus ir Girėno Vid. Mokylla, Radviliškis
2007

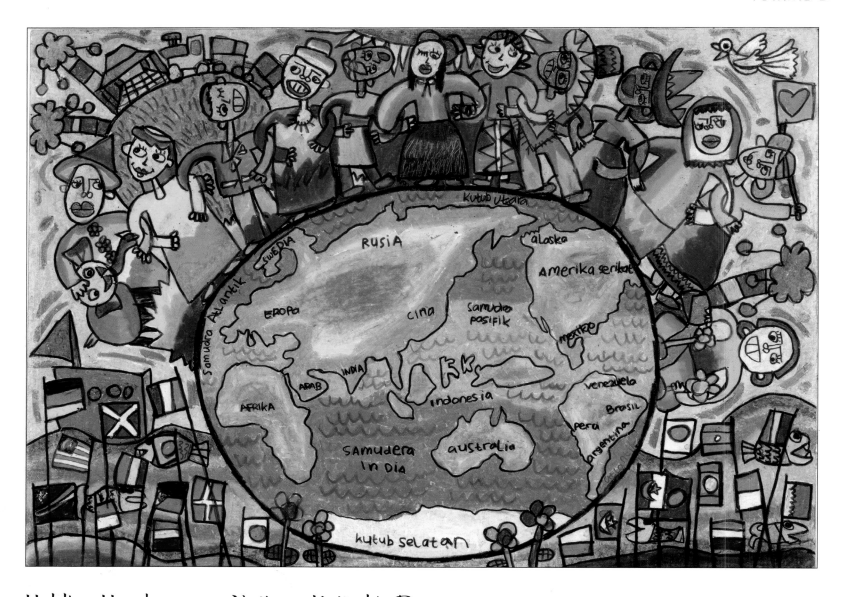

Holding Hands among Nations, United in Peace
Moh Afda
Age 7
Indonesia
Banguntapan, Bantul, Yogyakarta
2005

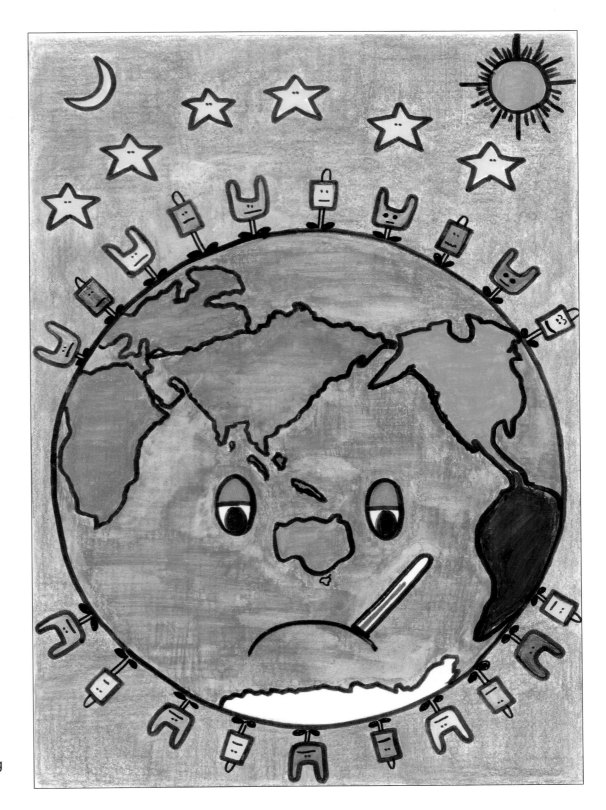

Use Less Plastic Bags
Brian Yang
Age 7
China
St. Johannes College, Hong Kong
2005

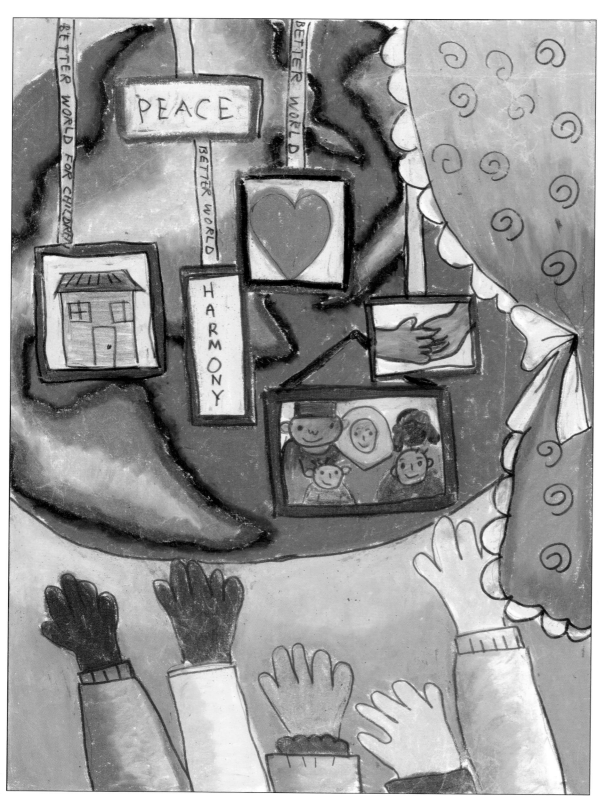

We Want to Live in the World That Is Peace and Harmony
Muhammad Fiqwan bin Noorazari
Age 7
Malaysia
Sekolah Kebangsaan Ampang,
Ampang, Selangor
2007

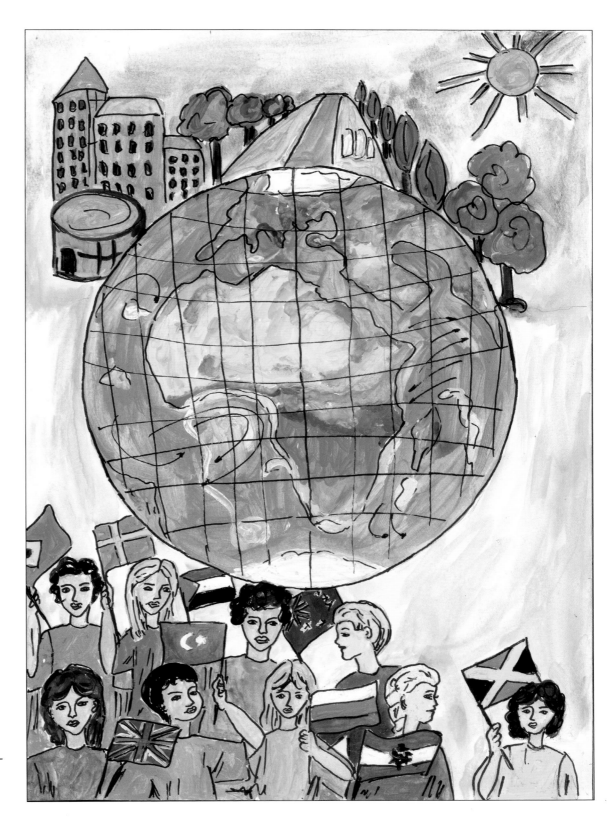

All Together for a
Common World
Anna Parvanova
Age 8
Bulgaria
Municipality Children Center—
Painting Art School, Plovdiv
2007

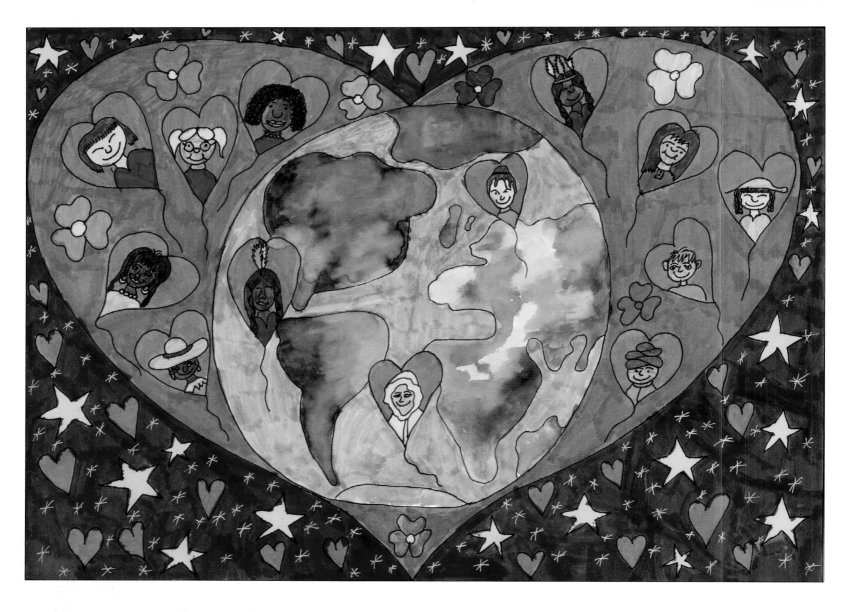

Live in Peace on the Earth!
Melita Papp and Viktória Tálas
Age 8
Hungary
Elek Benedek Elementary School, Debrecen
2007

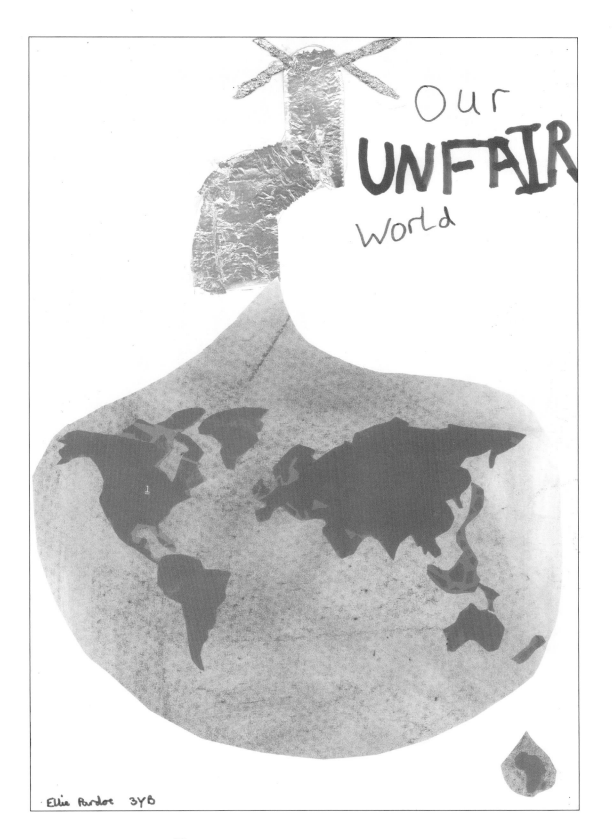

Our Unfair World
Ellie Pardoe
Age 8
United Kingdom
Ley Hill School, Chesham, Bucks
2007

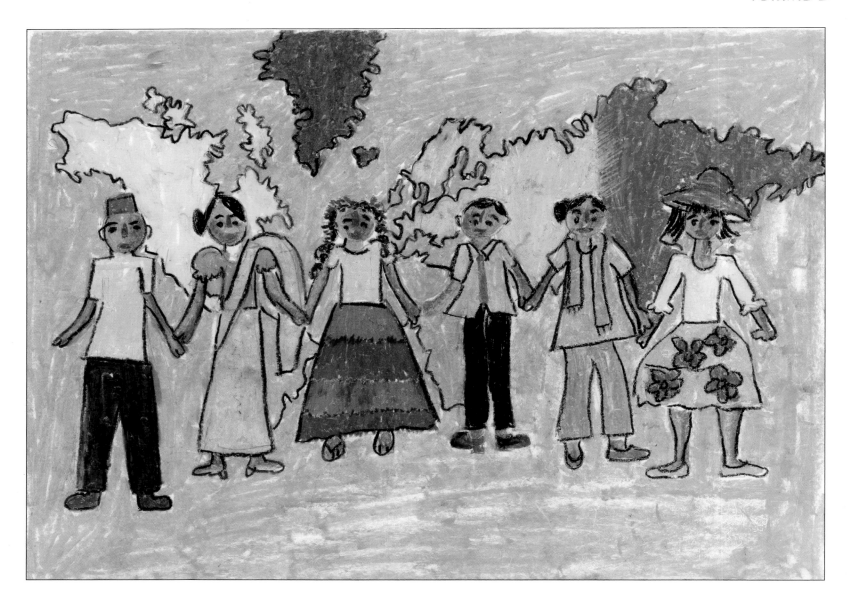

Many Nations, One World
Shashini Umasha Jayawardena
Age 8
Sri Lanka
Visakha Vidyalaya, Colombo
2005

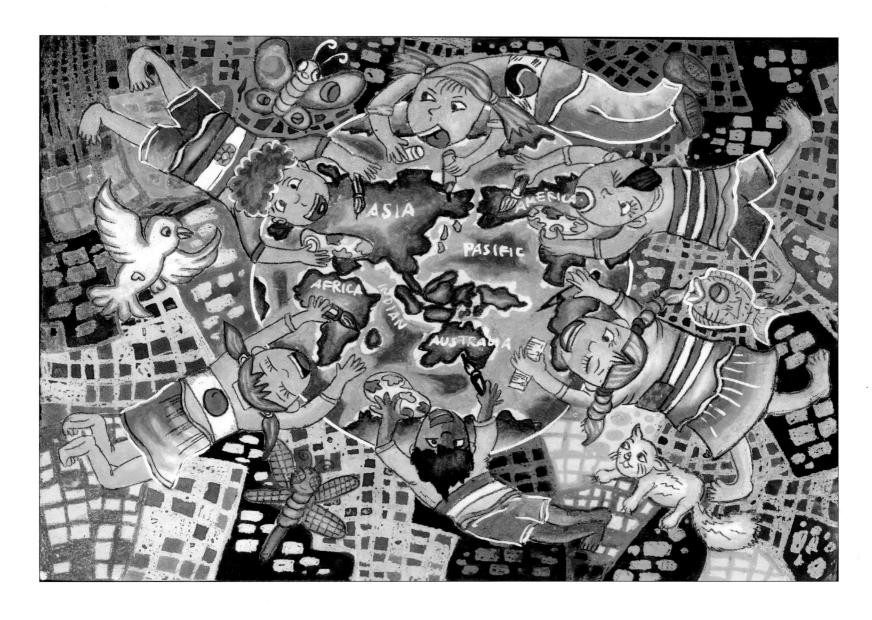

My Creation, My World
M. Yafie Abdillah
Age 8
Indonesia
SD Bani Saleh 6, Bekasi, West Java
2007

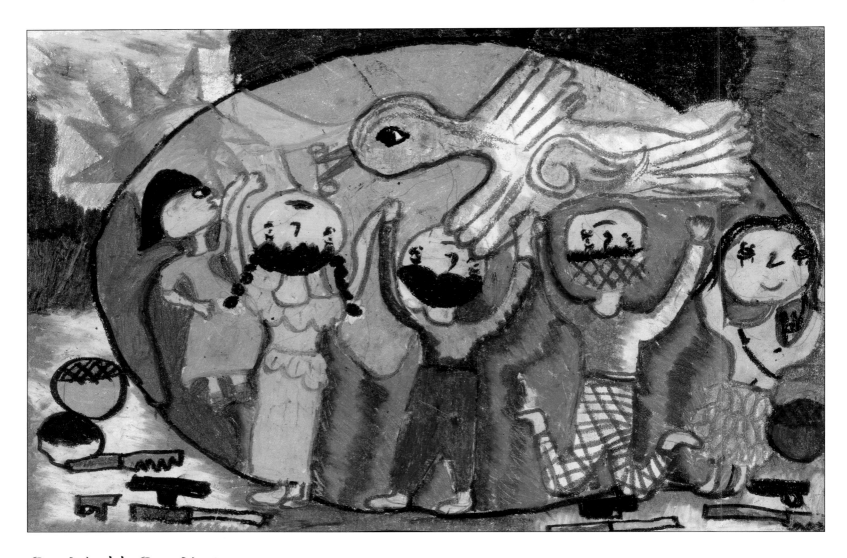

One World, One Nation
Paliyapana Natasha Sandalika Wijayarathne
Age 8
Sri Lanka
Gothami Vidyalaya, Gampaha
2007

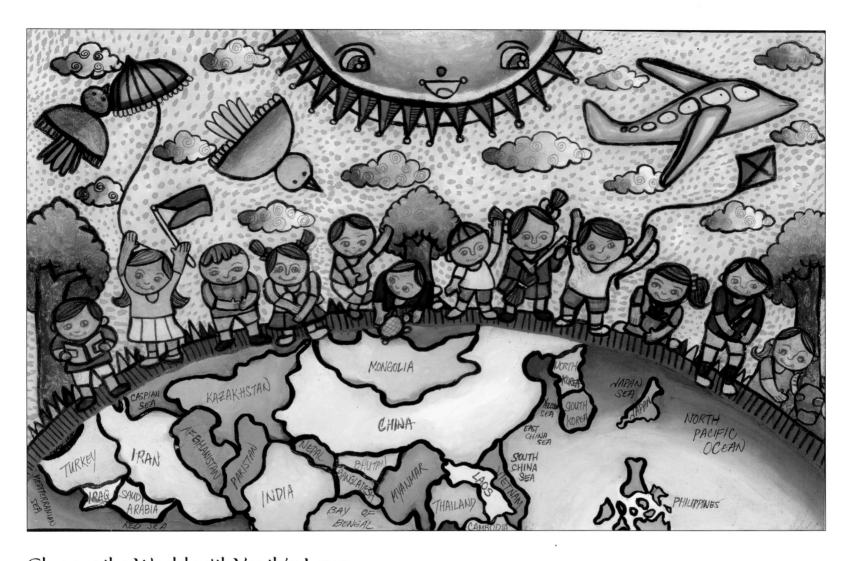

Shower the World with Youth's Love
Trisha C. Reyes
Age 8
Philippines
St. Stephen's High School, Manila
2007

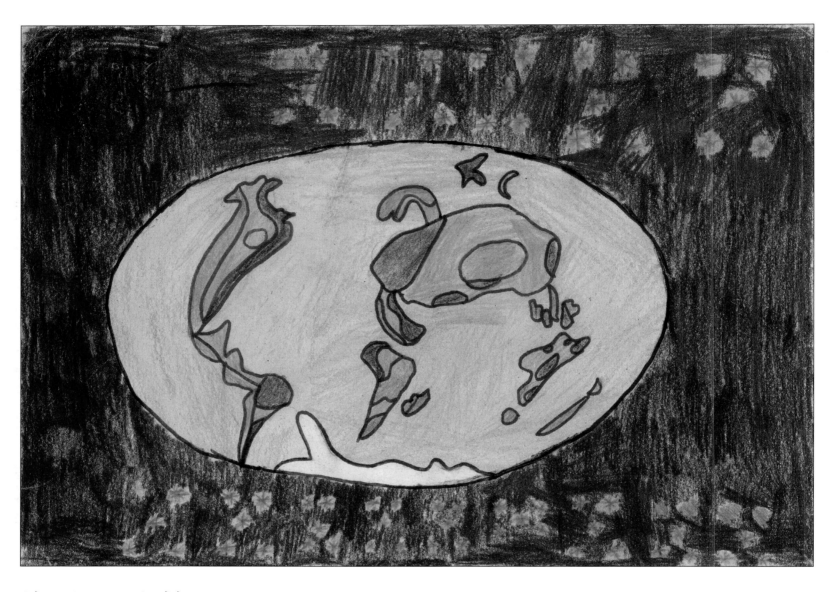

This Is My World!
Dóra Czinege
Age 8
Hungary
Elementary School, Budapest
2005

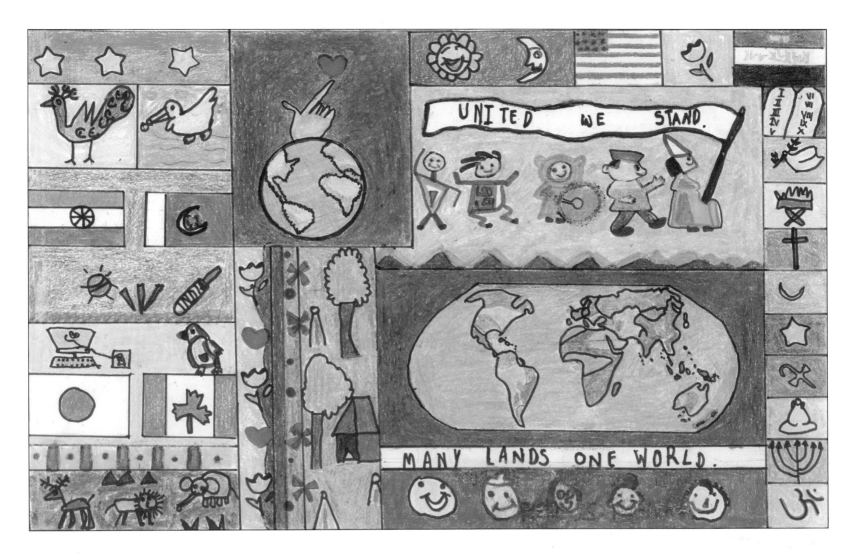

United We Stand
Aashvit Alkesh Goyal
Age 8
India
St. Kabir School, Ahmedabad
2005

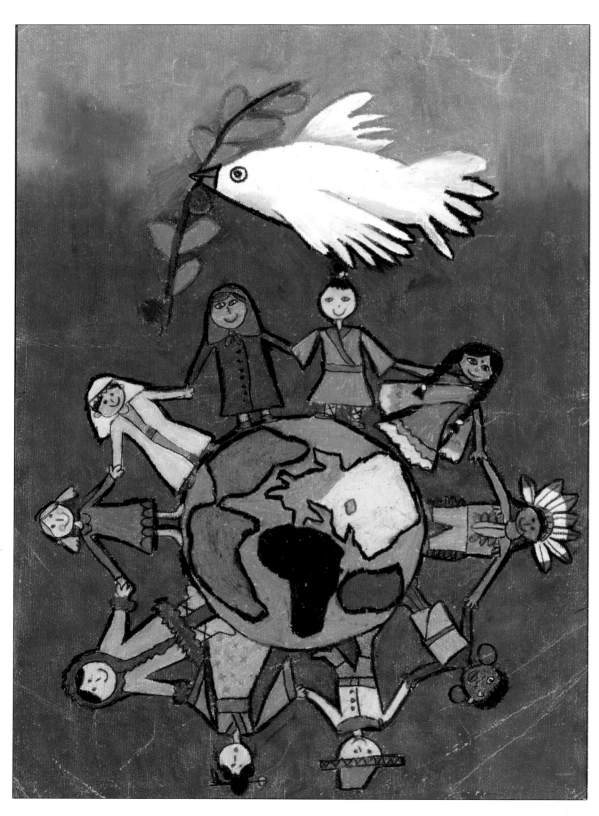

Untitled
Bita Porrang
Age 8
Iran
Adl, Tehran
2007

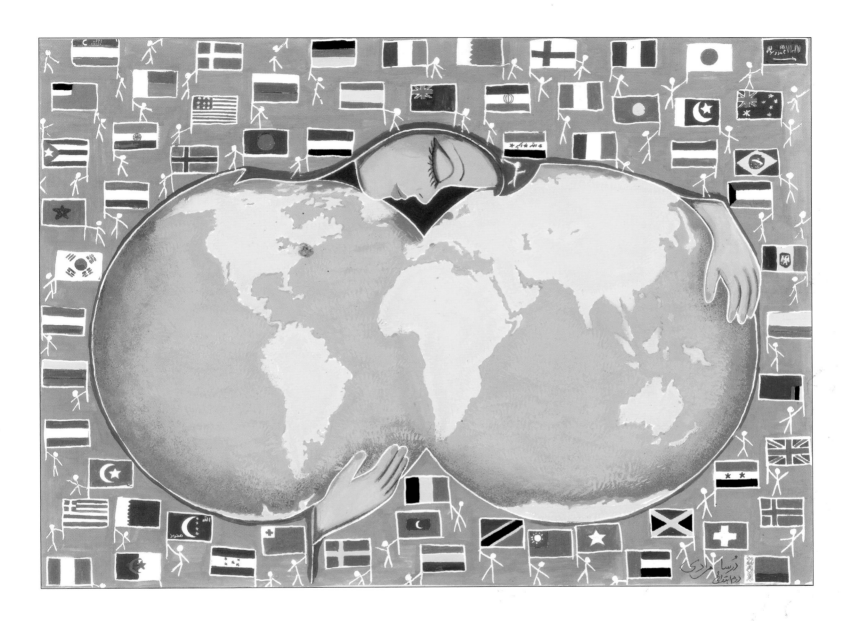

Untitled
Dorsa Moradi
Age 8
Iran
Bargozidegan, Tehran
2005

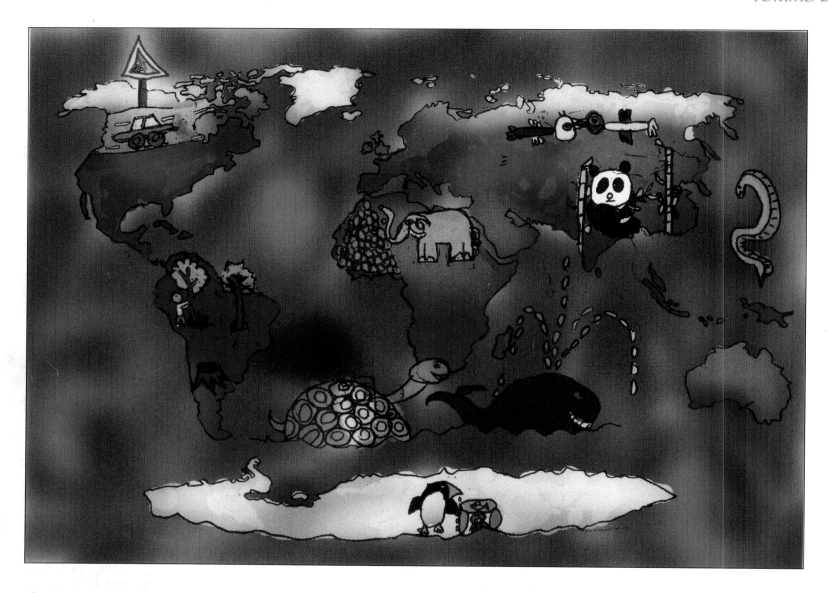

Common Home
Yifeng Ni
Age 9
China
Juqianjie Primary School, Changzhou
2007

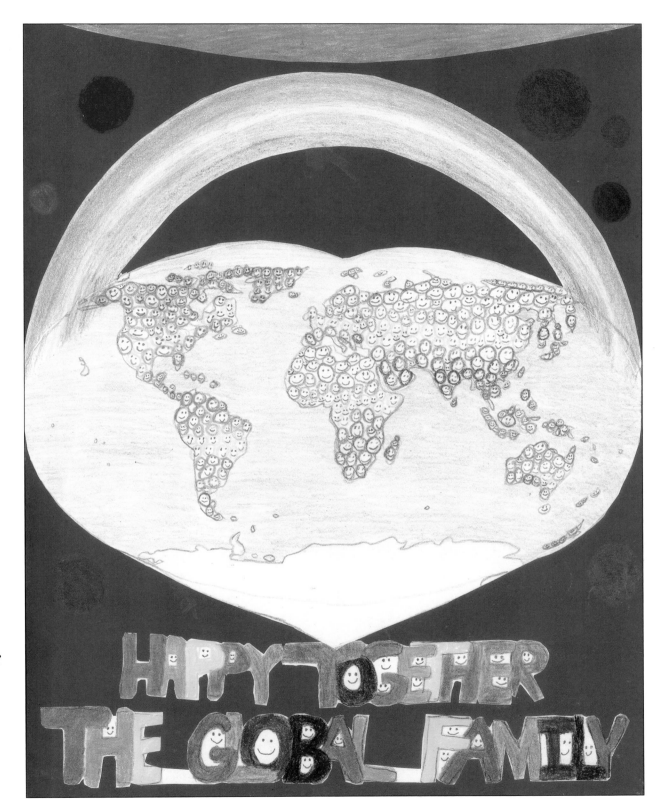

Happy Together, the Global Family
Megan Chao
Age 9
United States
Garrett Park
Elementary School,
Garret Park, Maryland
2005

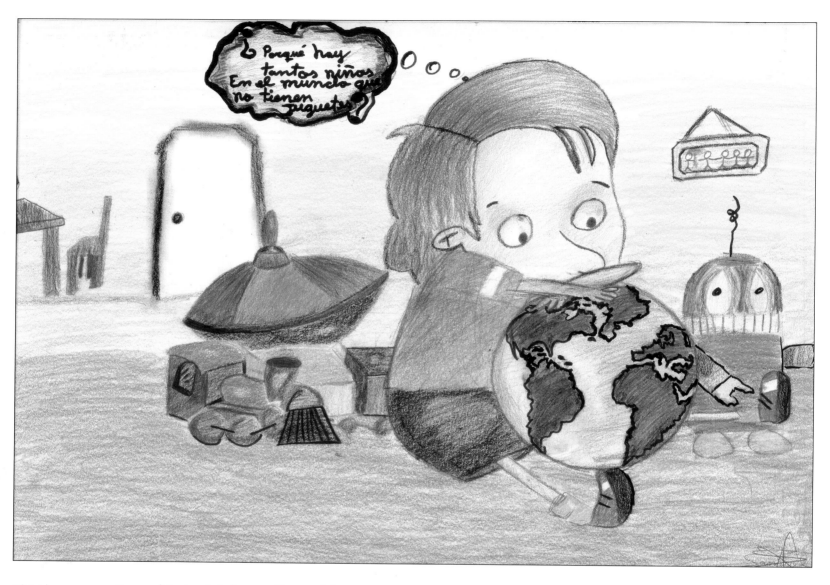

I Want an Equal World for All (Public award)
Samuel Zúñiga Vélez
Age 9
Spain
Colegio San Ignacio de Loyola, Alcala de Henares
2007

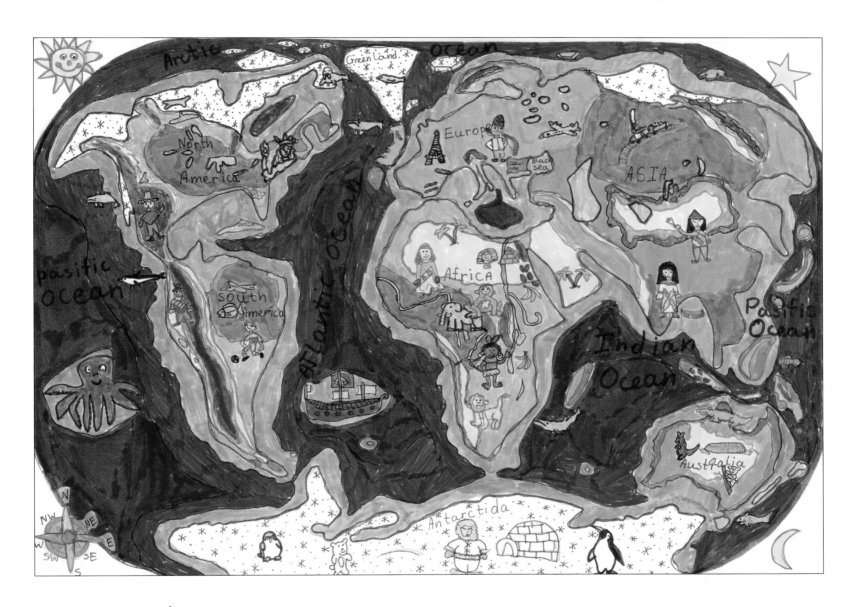

Let's Be Friends
Alexandar Veselinov Angelov
Age 9
Bulgaria
Art School "Spektar," Sofia
2005

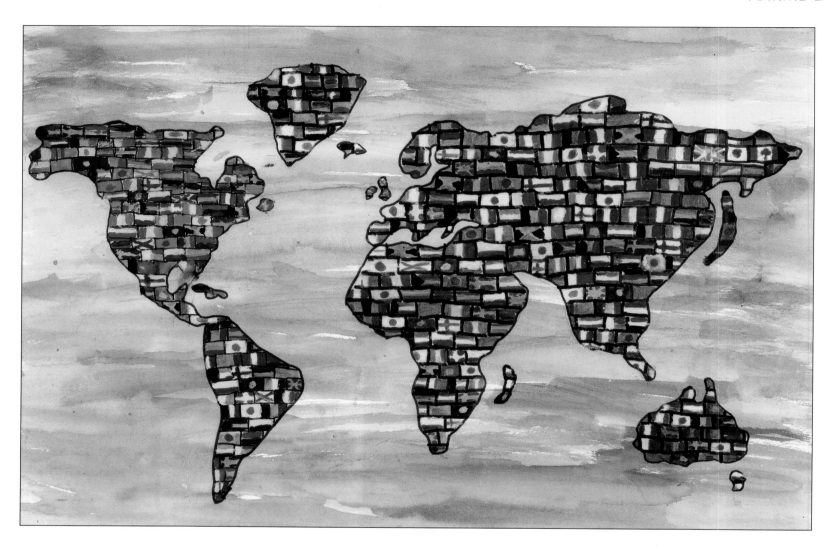

Many Nations, One World
Sophia Liu
Age 9
United Kingdom
St. Hugh's Primary School, Timperley, Cheshire
2007

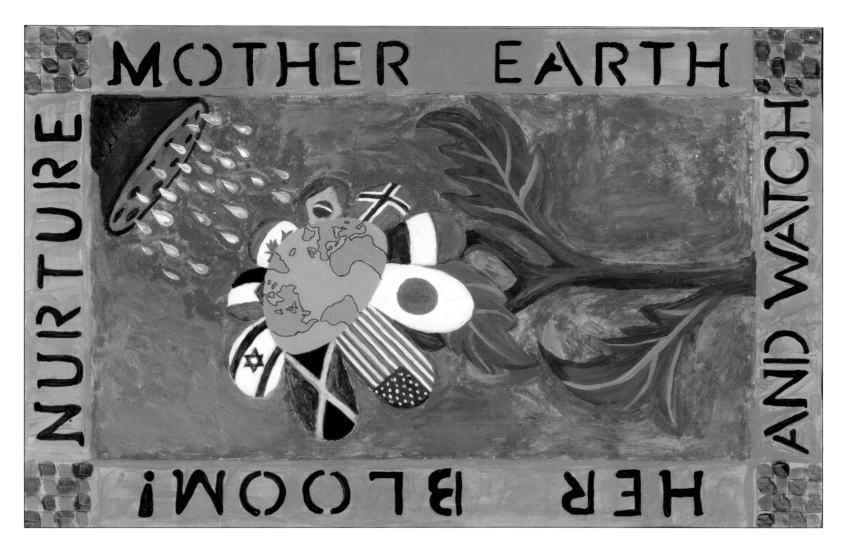

Nurture Mother Earth and Watch Her Bloom
Brooke Angaran
Age 9
United States
Mt. Horeb Intermediate Center, Mt. Horeb, Wisconsin
2007

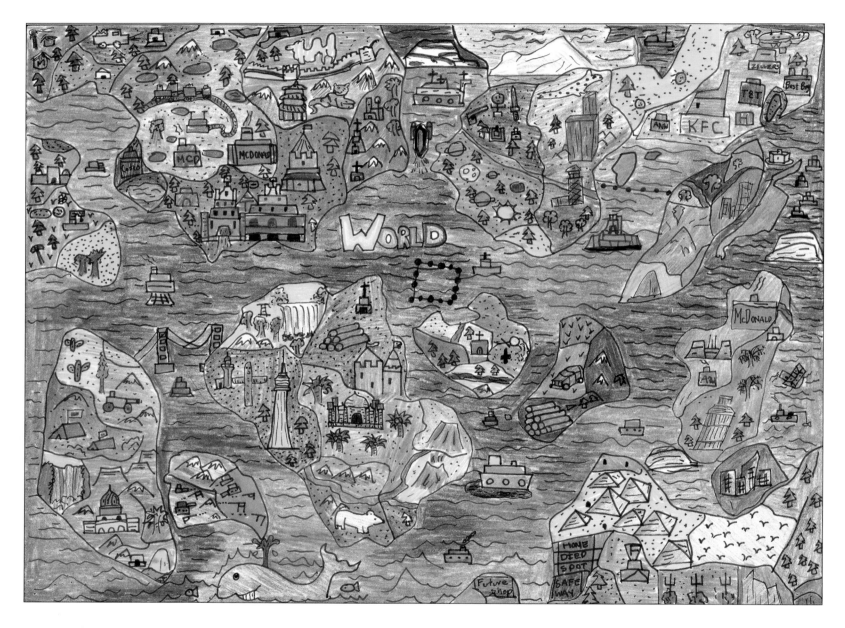

Save the World
Kevin Wu
Age 9
Canada
Walton Elementary School, Coquitlam, British Columbia
2007

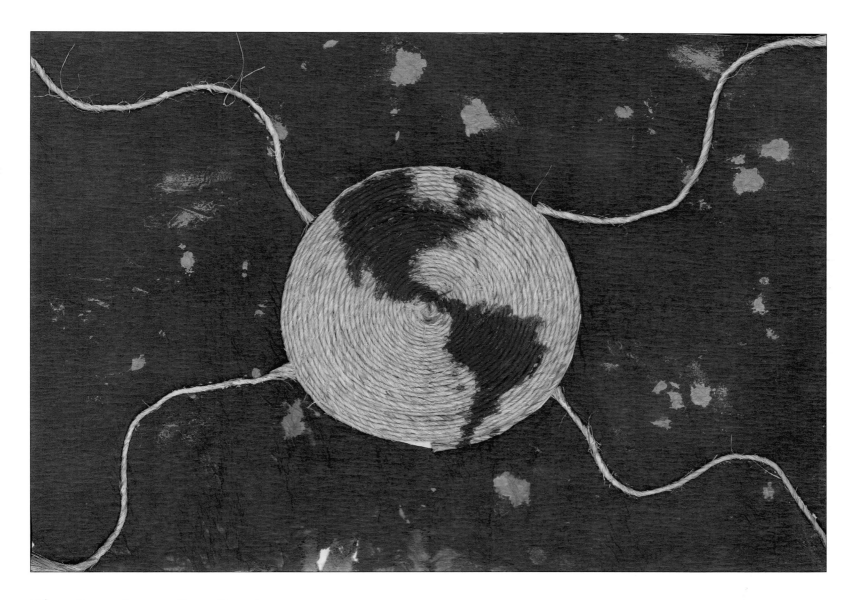

The Americas, Our Continent
María Agostina Raffí
Age 9
Argentina
Instituto San Luis Gonzaga, Buenos Aires
2007

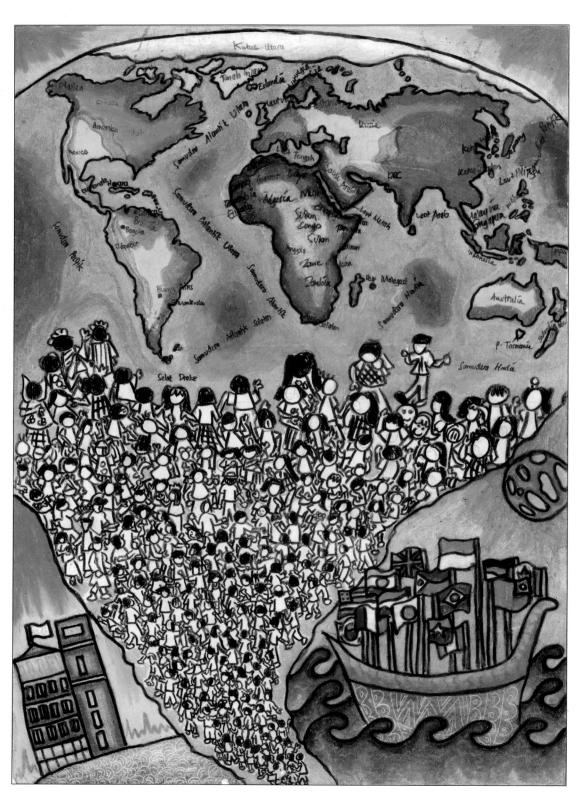

The Bright New World
Yumna Anindya Pangesti
Age 9
Indonesia
SD Negeri Ngablak, Bangunkerto,
Turi, Sleman, Yogyakarta
2005

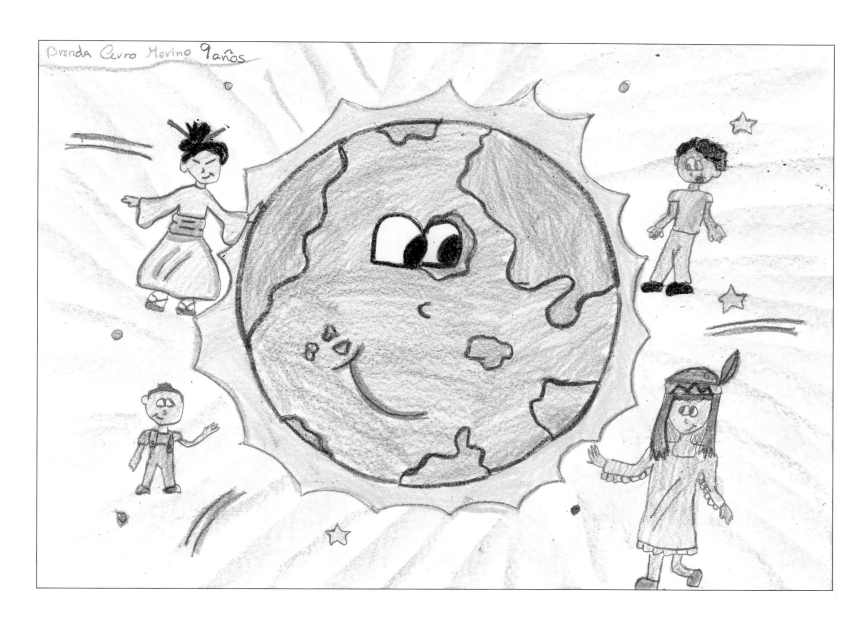

Untitled
Brenda Cerro Merino
Age 9
Spain
CP Asunción Rincón, Madrid
2005

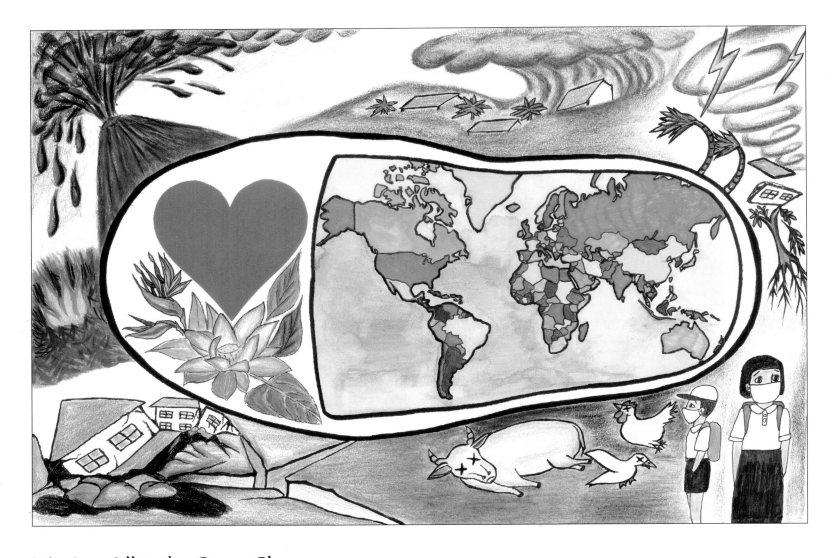

We Are All in the Same Shoe
Victoria Lan
Age 9
Canada
Lochside Elementary School, Victoria, British Columbia
2005

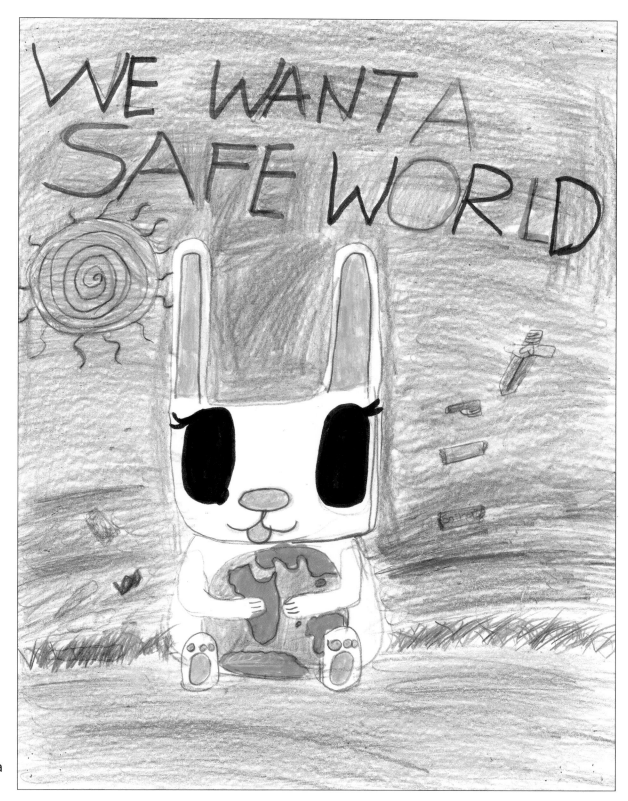

**We Want A
Safe World**
Se On Lee
Age 9
Canada
Walton Elementary School,
Coquitlam, British Columbia
2007

Age 10–11

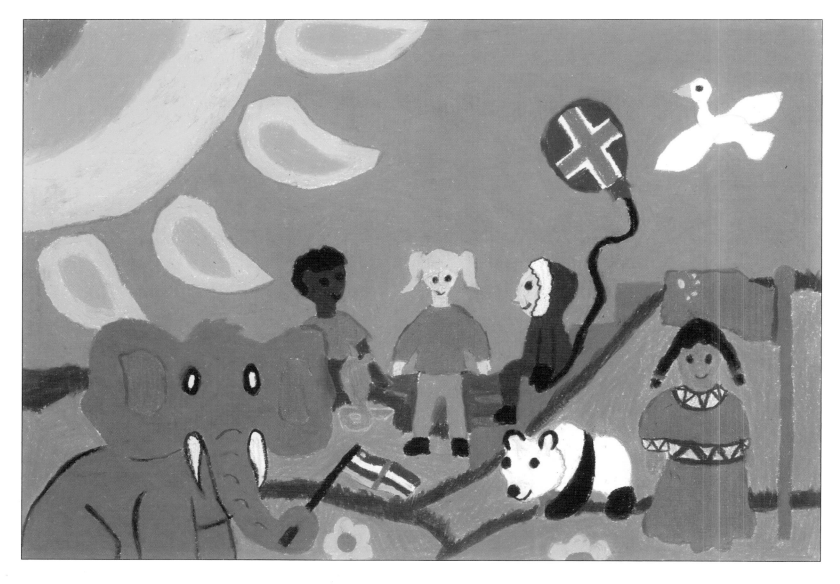

All Children under the Same Sun
Pauli Saha
Age 10
Finland
Hyökkälän Koulu, Tuusula
2005

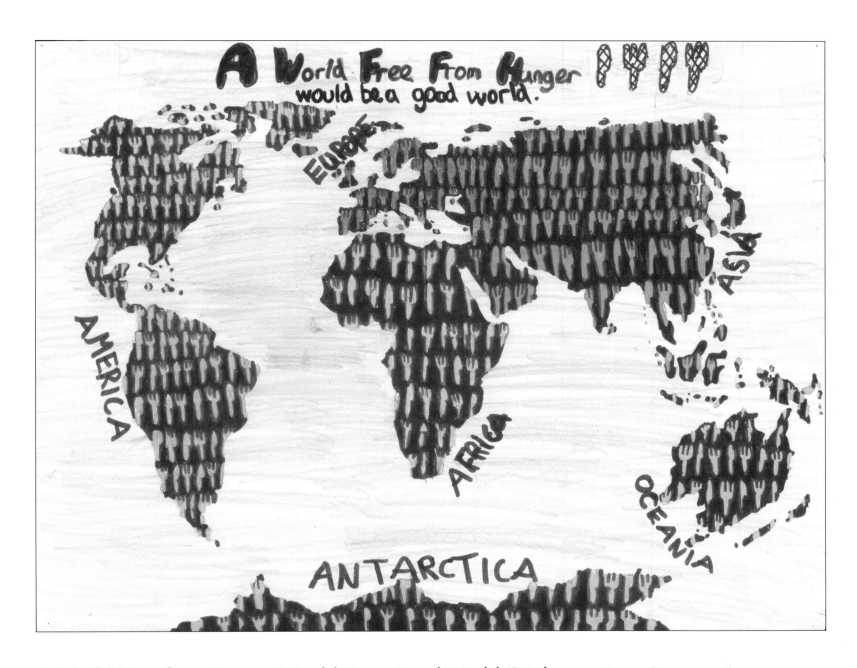

A World Free from Hunger Would Be a Good World (Diploma winner)
Holly Harrison
Age 10
United Kingdom
Christ Church CE (C) Primary School, Lichfield, Staffs
2005

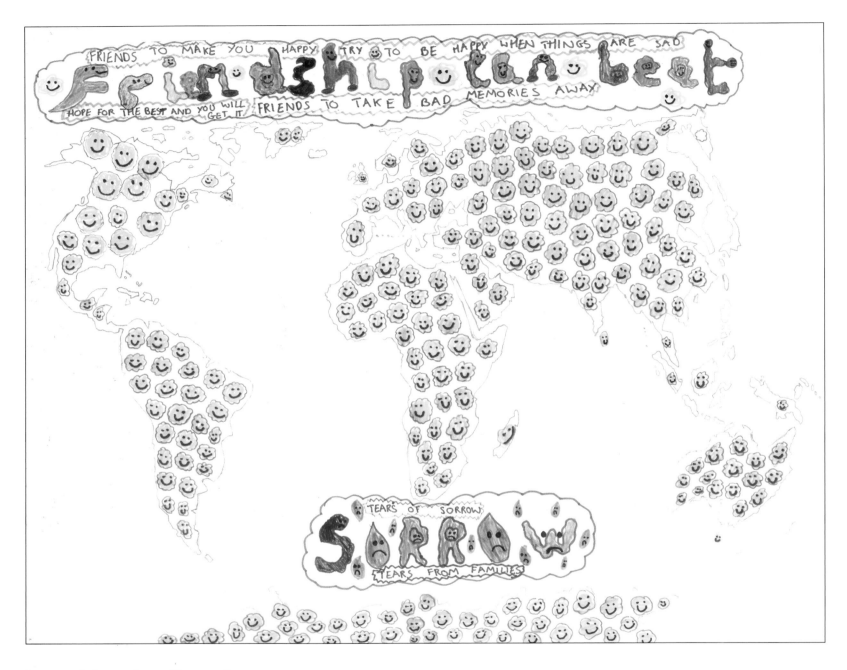

Friendship Can Beat Sorrow
Kaitlin Wray
Age 10
United Kingdom
Christ Church CE (C) Primary School, Lichfield,
Staffs
2005

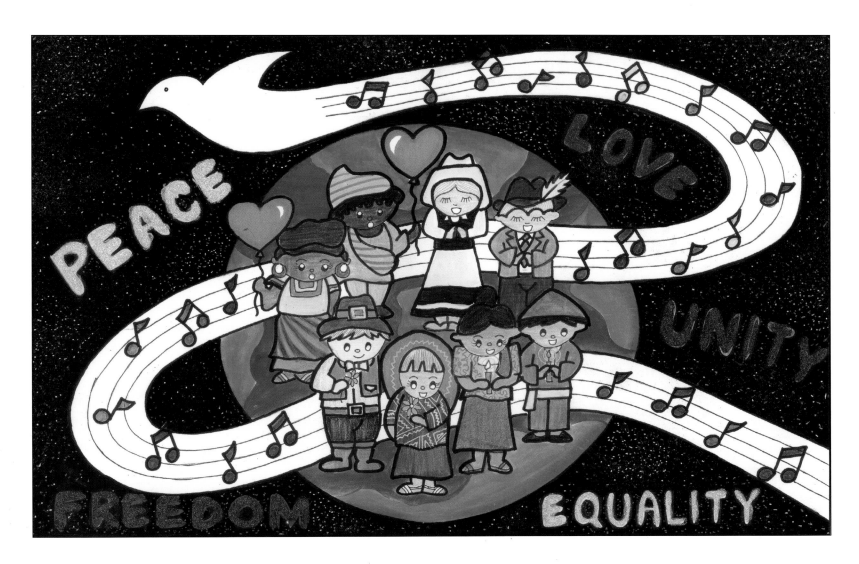

Give Peace a Chance
Jerrika C. Shi
Age 10
Philippines
St. Jude Catholic School, Manila
2007

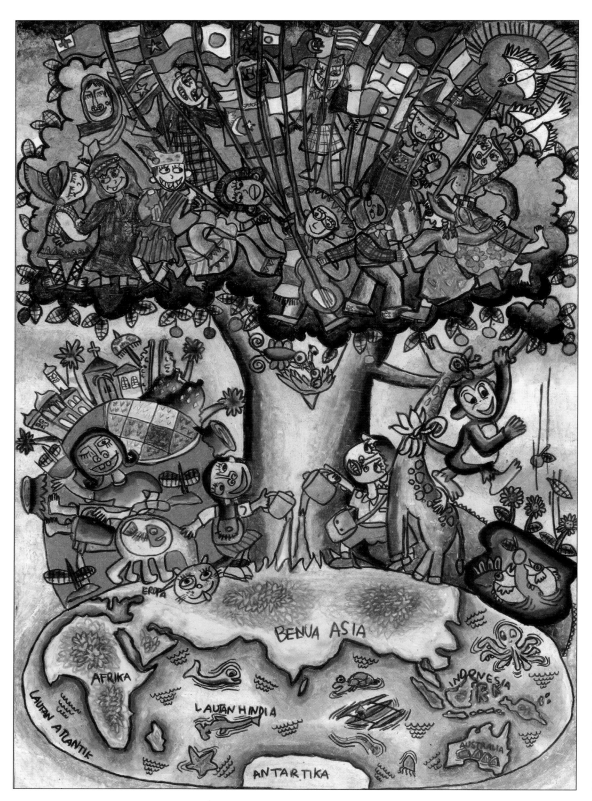

Let's Make Our World
Merrier with Smiles
of United Nations
Nayafakda Ihsania
Age 10
Indonesia
SD Muhammadiyah, Sapen,
Gondokusuman, Yogyakarta
2005

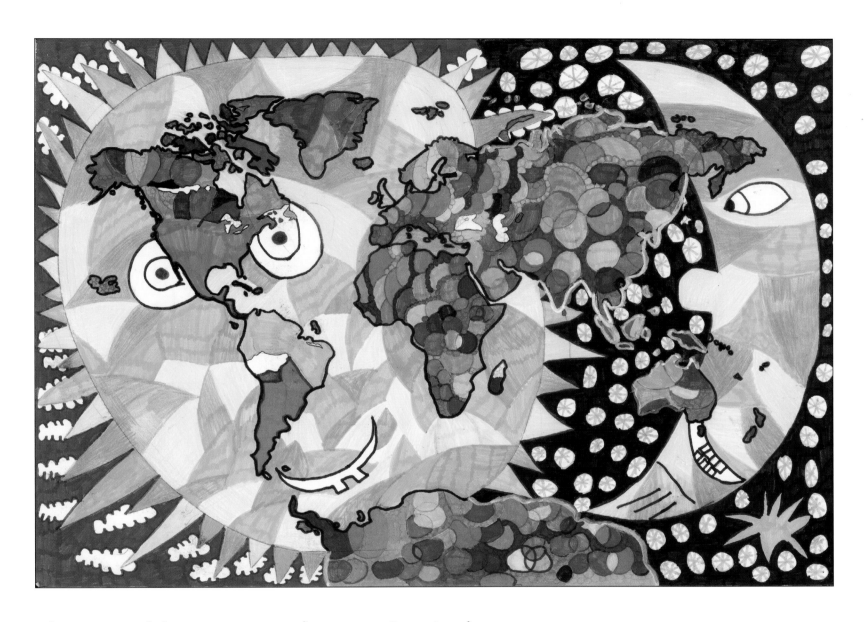

The Sun and the Moon Are Shining to Our Earth
Lucie Mertová
Age 10
Czech Republic
ZŠ a MŠ, Jindřichov
2007

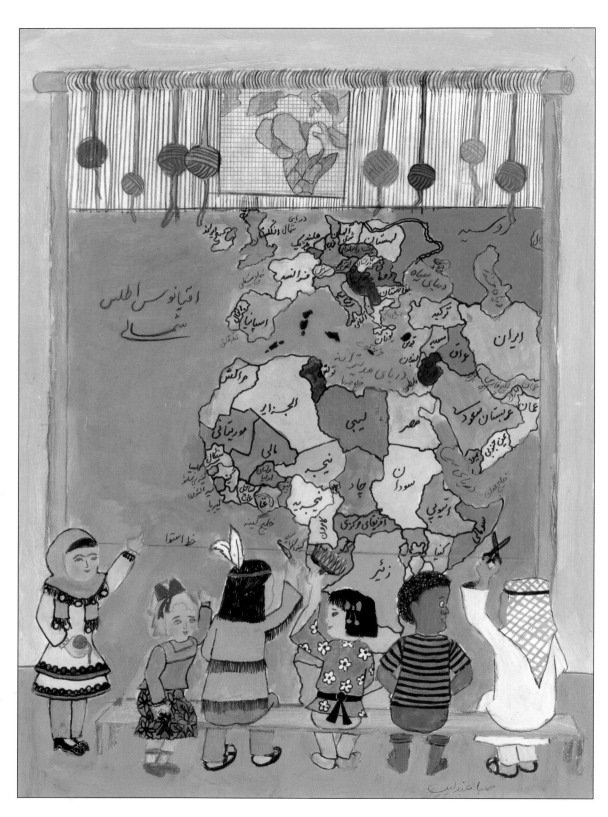

Untitled
Saba Andalib
Age 10
Iran
Salman, Tehran
2005

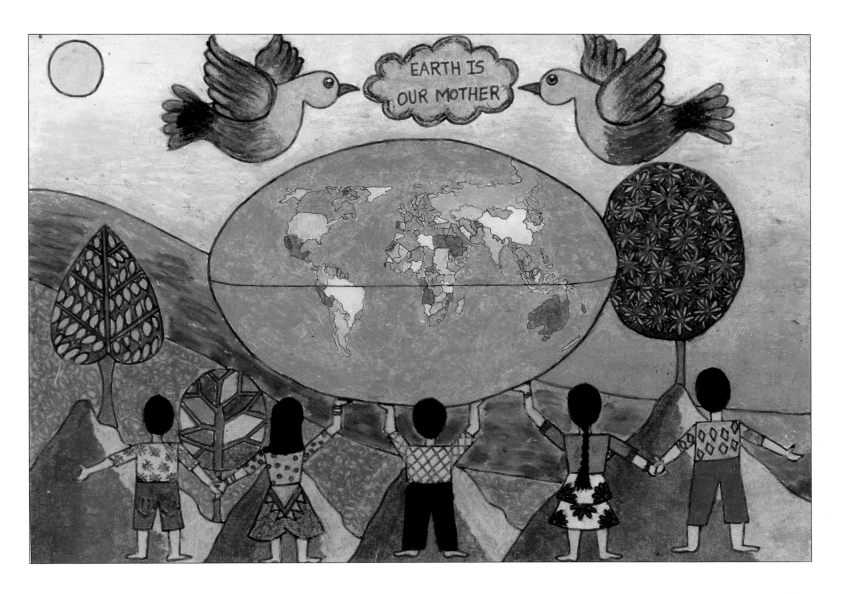

We and Our Mother Earth
Avani Nilesh Shah
Age 10
India
St. Kabir School, Ahmedabad
2005

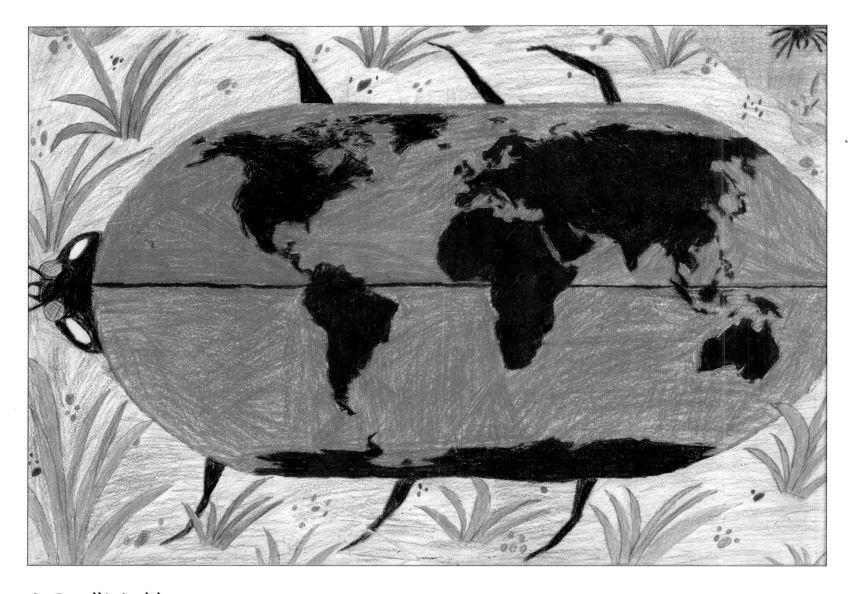

A Small World
Alex Ballagh
Age 11
Canada
Codrington Public School, Barrie, Ontario
2005

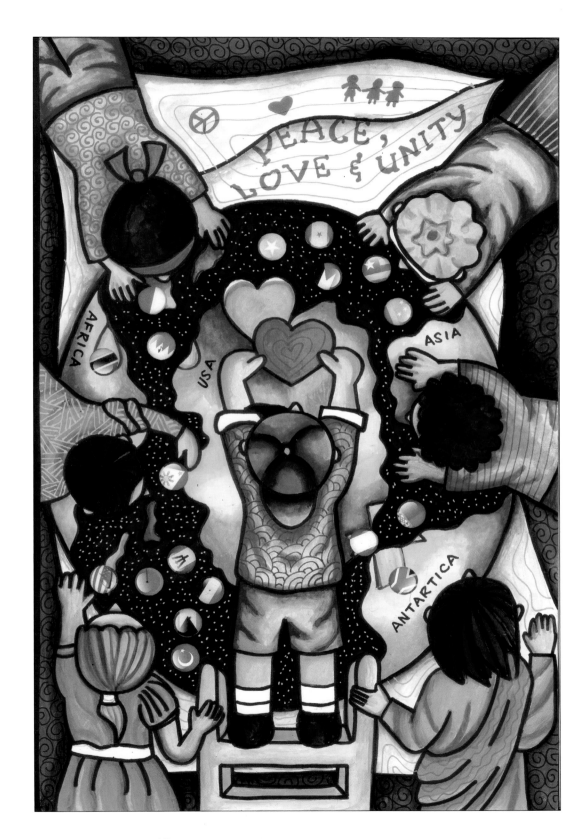

Building a Nation of Love,
Peace, and Unity
Ryanna C. Tee
Age 11
Philippines
St. Jude Catholic School, Manila
2007

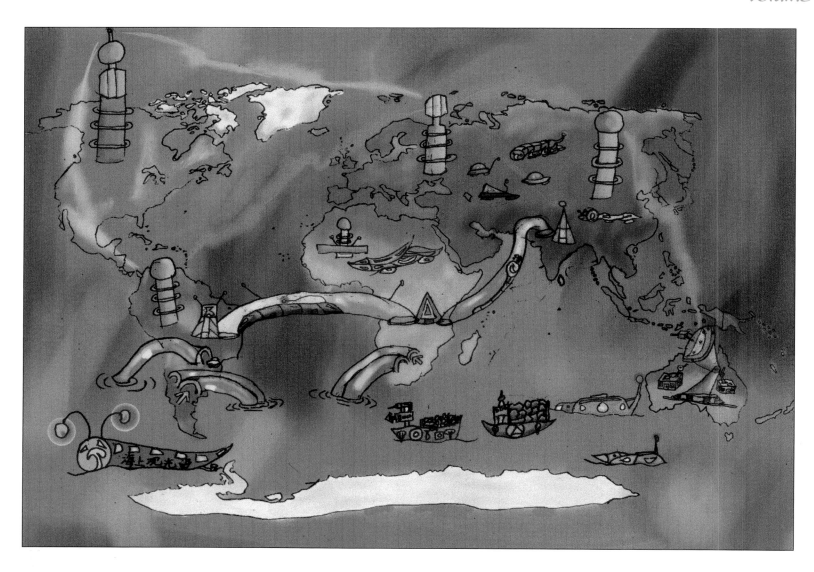

Communication
Jiacheng Sun
Age 11
China
Huayuan Primary School, Changzhou
2007

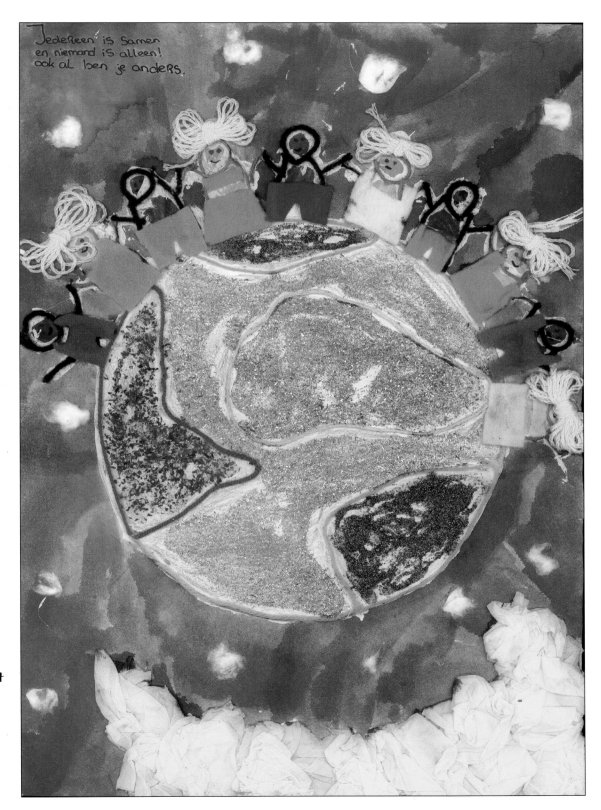

*Everyone Belongs and
No One is Alone,
Even if One Is Different*
Rozemarijn van Krugten
Age 11
Netherlands
CBS Acaciahof,
loc. Zuidsingel, Middelburg
2007

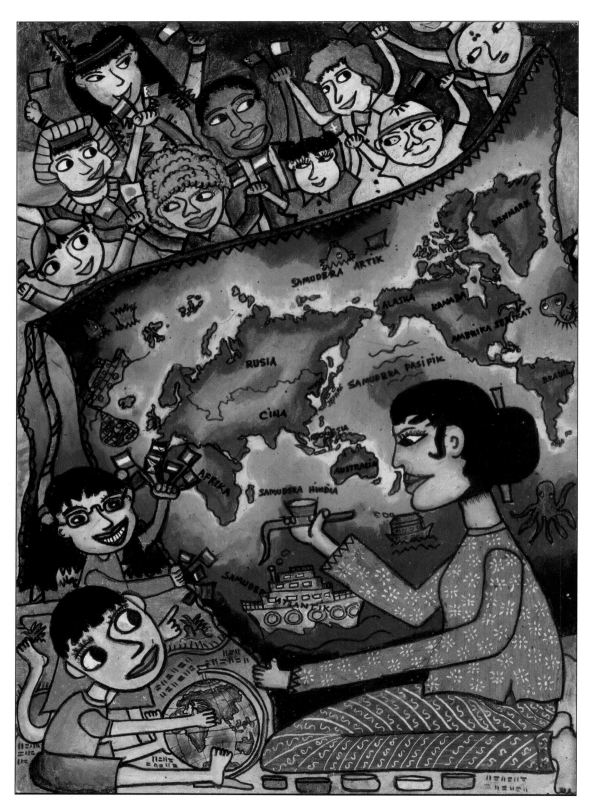

Javanese Traditional
Painting (Membatik)
Fadilah Dina Putri
Age 11
Indonesia
SD Muh Sokonandi,
Yogyakarta, DIY
2007

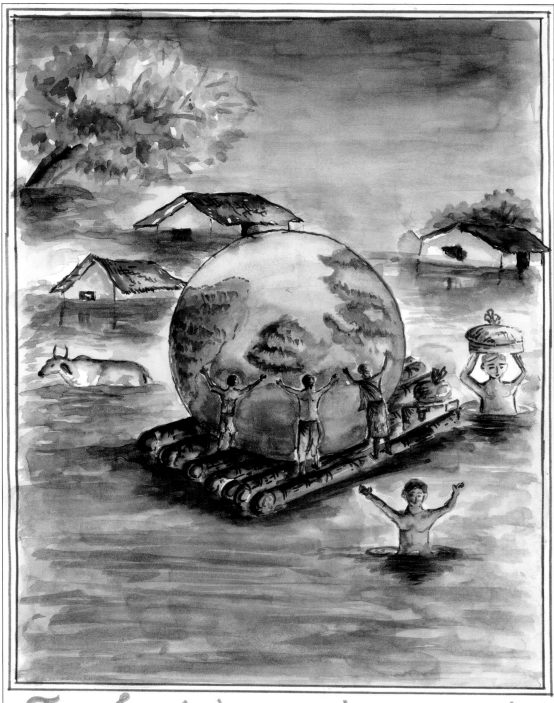

Join Hands to Prevent Jeopardy to Nature
Suhita Nath
Age 11
India
BSF Senior Secondary Residential
School, Kadamtala, Dist. Darjeeling
2007

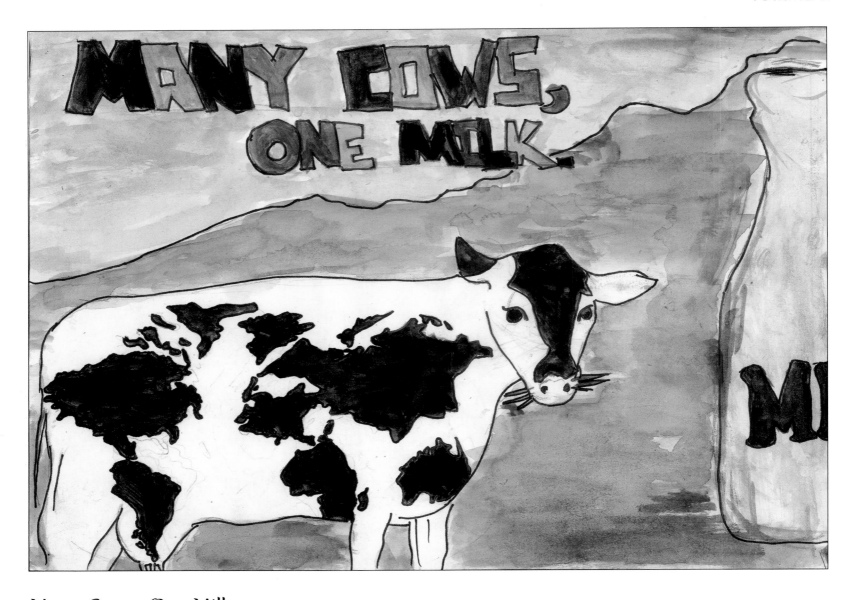

Many Cows, One Milk
Chan Mi Lee
Age 11
Malaysia
International School of Kuala Lumpur, Ampang, Selangor
2007

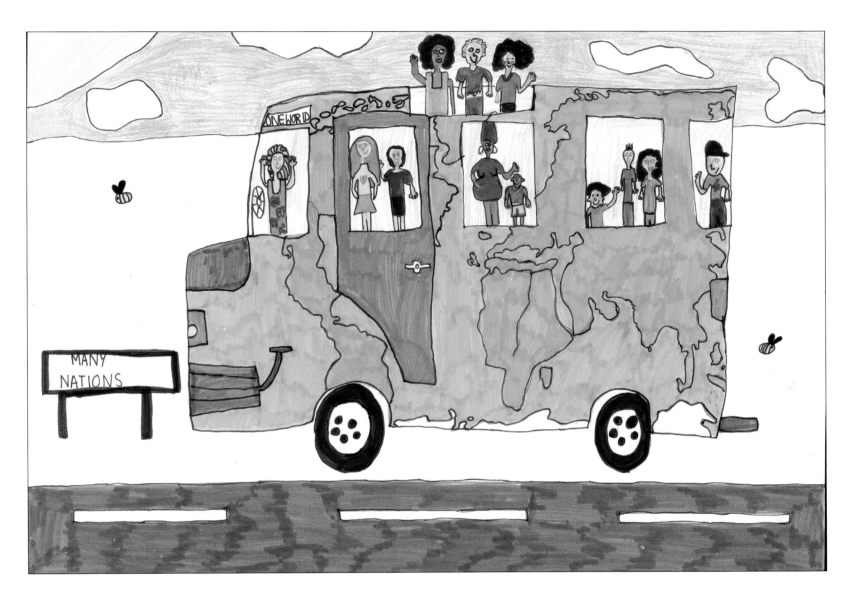

Many Nations, One World
Alexandra Gavin
Age 11
United Kingdom
St. Hugh's Primary School, Timperley, Cheshire
2007

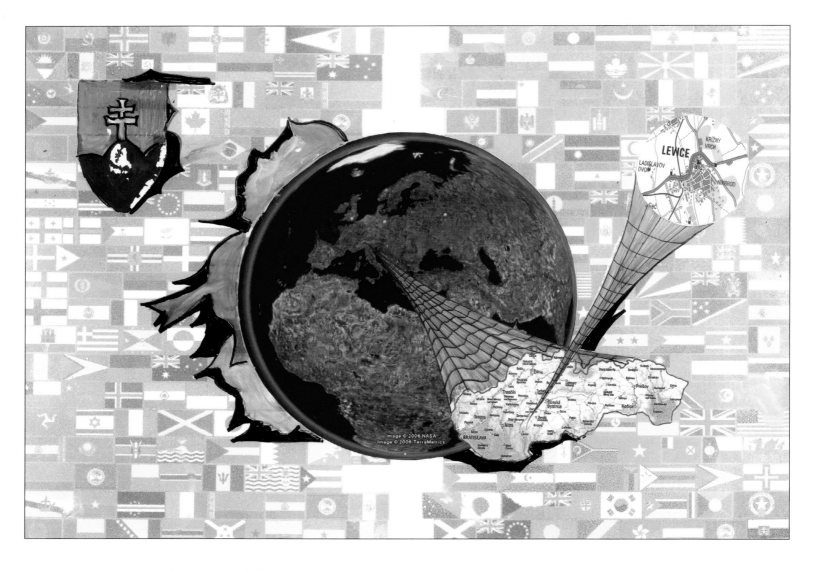

Many Nations, One World
Laura Ederová
Age 11
Slovak Republic
Primary School, Levice
2007

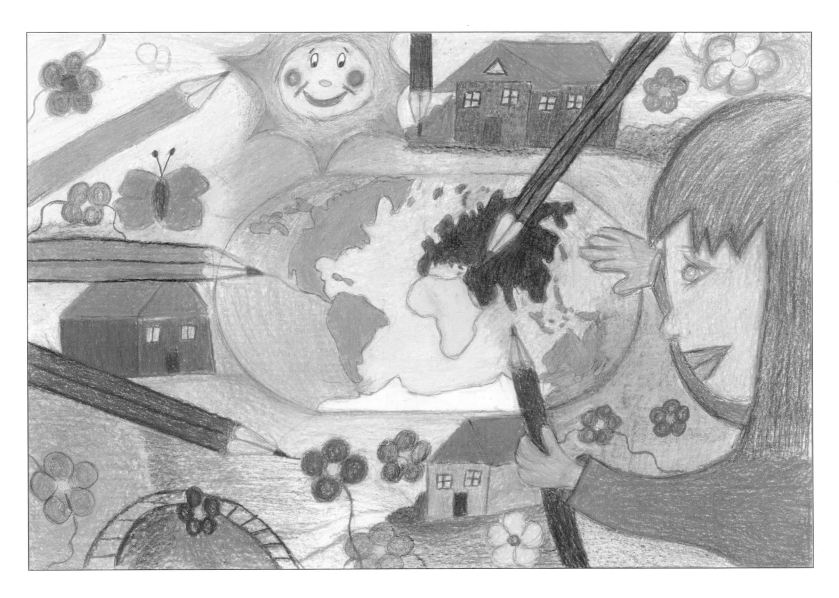

Many Nations, One World
Nikoleta Országová
Age 11
Slovak Republic
ZŠ Žarnovica, Žarnovica
2005

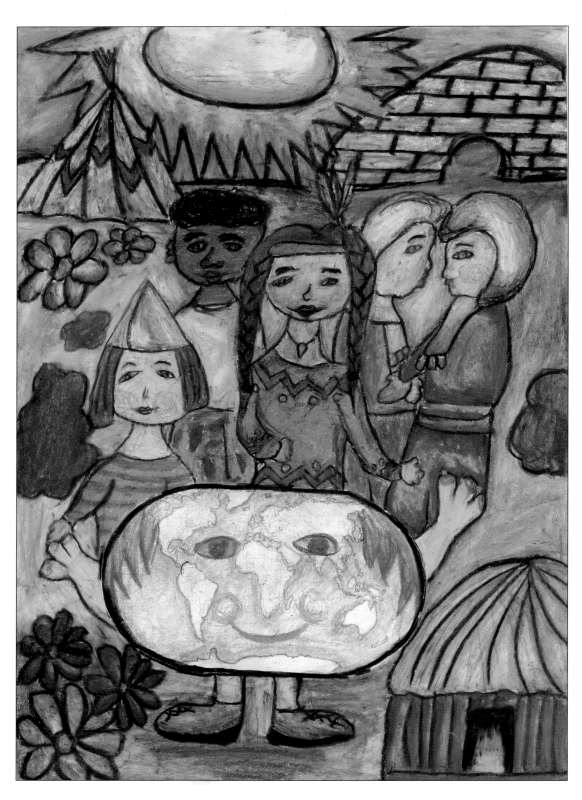

Many Nations, One World
Radka Vozárová
Age 11
Slovak Republic
ZŠ Žarnovica, Žarnovica
2005

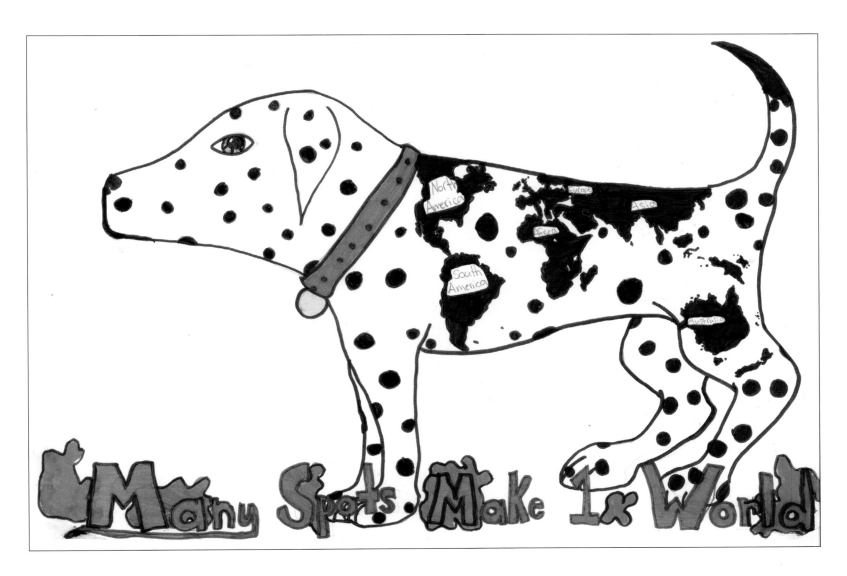

Many Spots Make One World
Kelsi Fraser-Easton
Age 11
Canada
Silverthorne Elementary School, Houston, British Columbia
2005

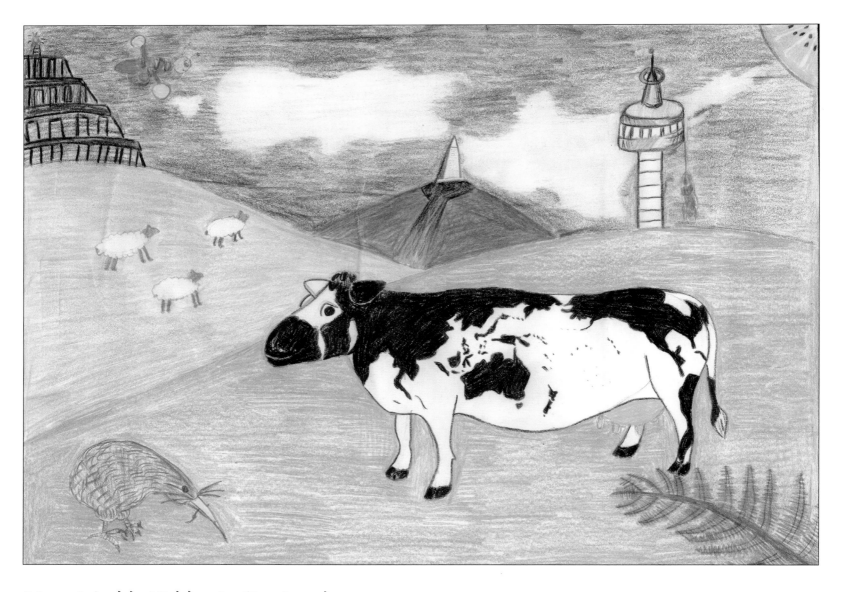

Many Worlds Hidden in Our Landscape
Hayden Livingstone
Age 11
New Zealand
Matahui Road School, Katikati
2007

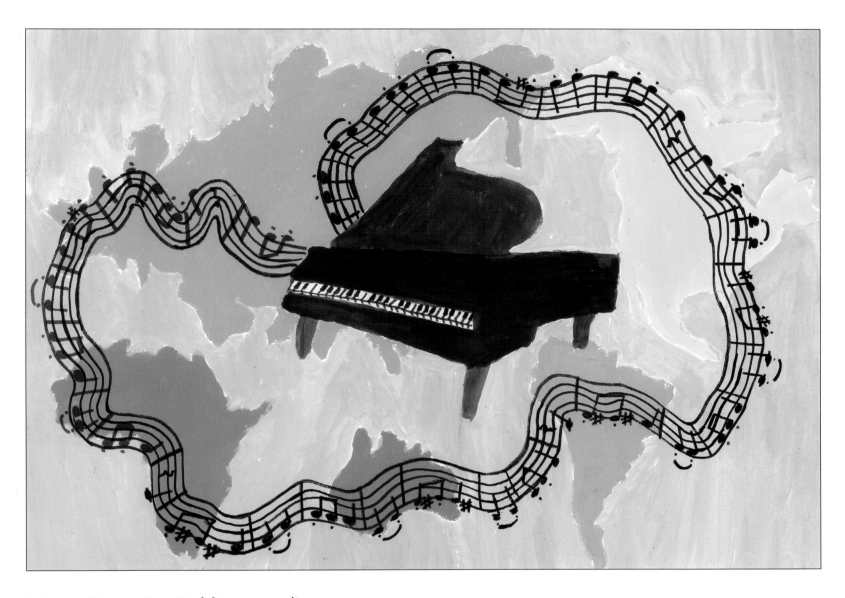

Music Joins Us (Public award)
Katarzyna Fojcik
Age 11
Poland
Szkoła Podstawowa nr. 1 im. Adama Mickiewicza, Marklowice
2007

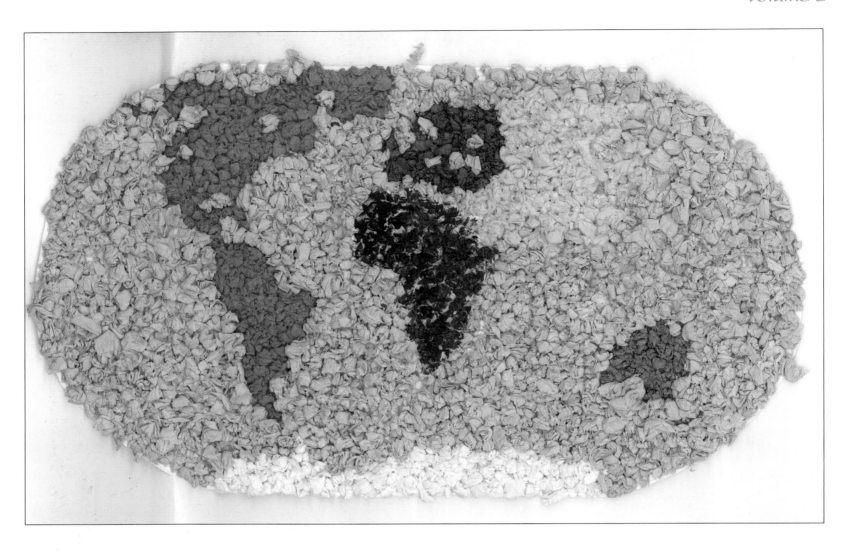

Peace All Over the World
Kateřina Čížová
Age 11
Czech Republic
ZŠ, Vítkov
2005

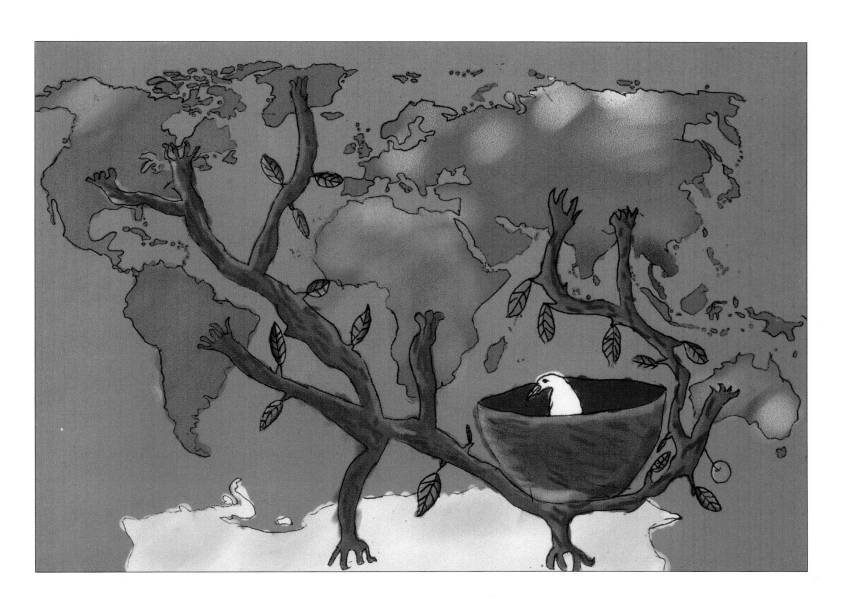

Roots of the Peace
Yunjie Qian
Age 11
China
Miduqiao Primary School, Changzhou
2007

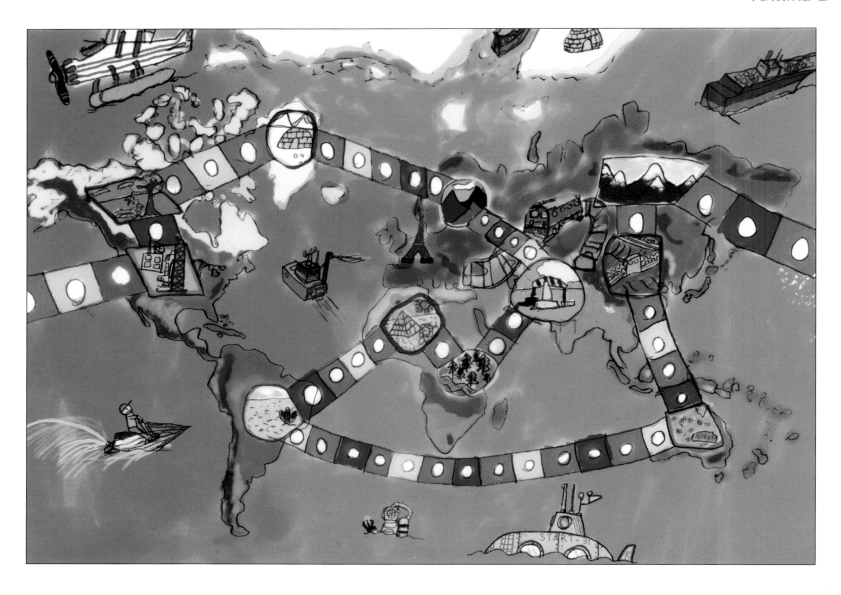

The World is Just Like a Chess
Biaoyunke Zhang
Age 11
China
Colorful Castle Children's Art Studio, Changzhou
2005

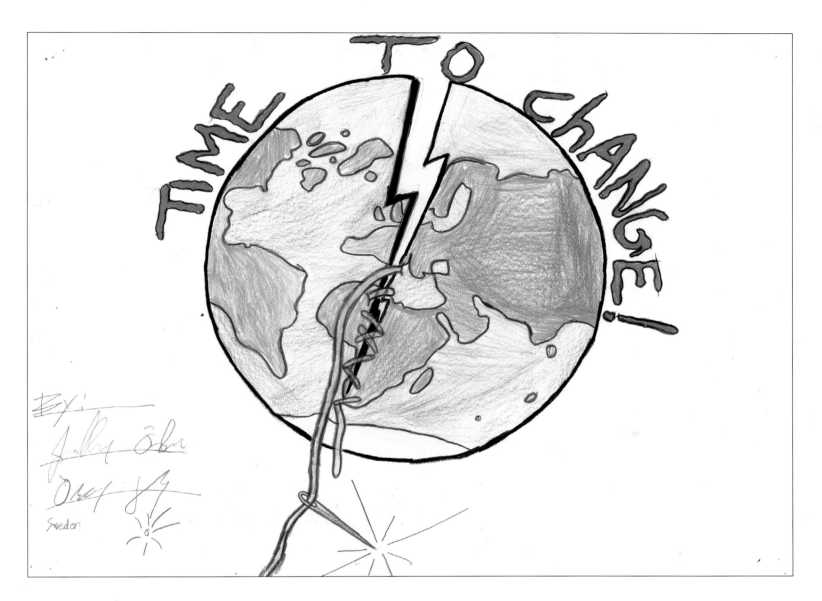

Time to Change
Jonathan Öderyd
Age 11
Sweden
Maria Elementary School, Stockholm
2007

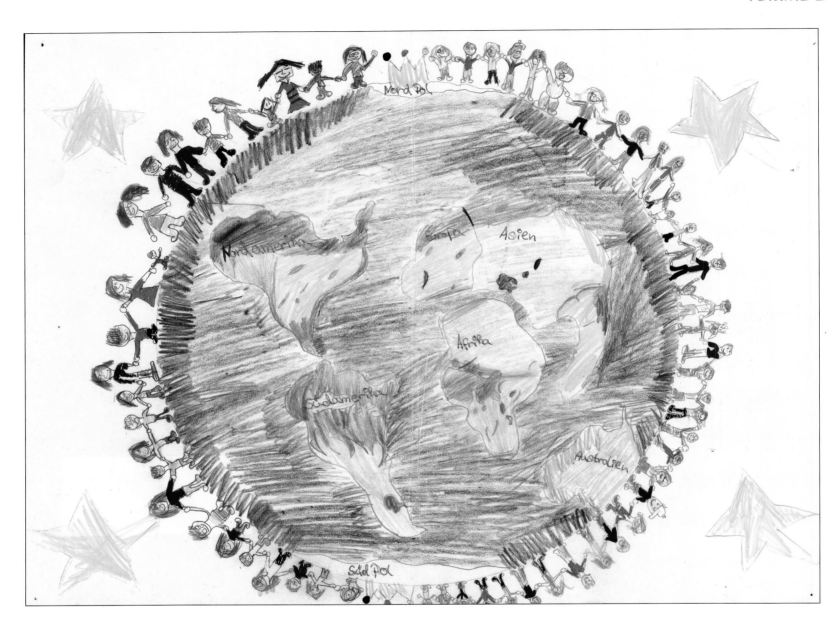

We Are a Lot of Different Nations, but All Together
Clarissa Damm
Age 11
Germany
Kooperative Gesamtschule "Am Schwemmbach," Erfurt
2007

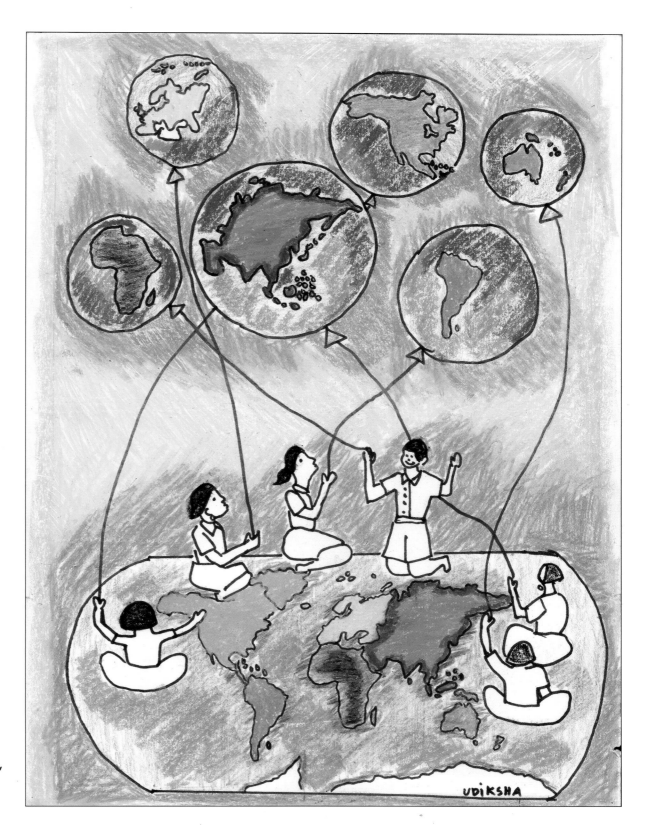

*We Children Have
the Same Dream*
Udiksha Nagaraj
Age 11
India
The Cathedral High School,
Bangalore
2007

Age 12

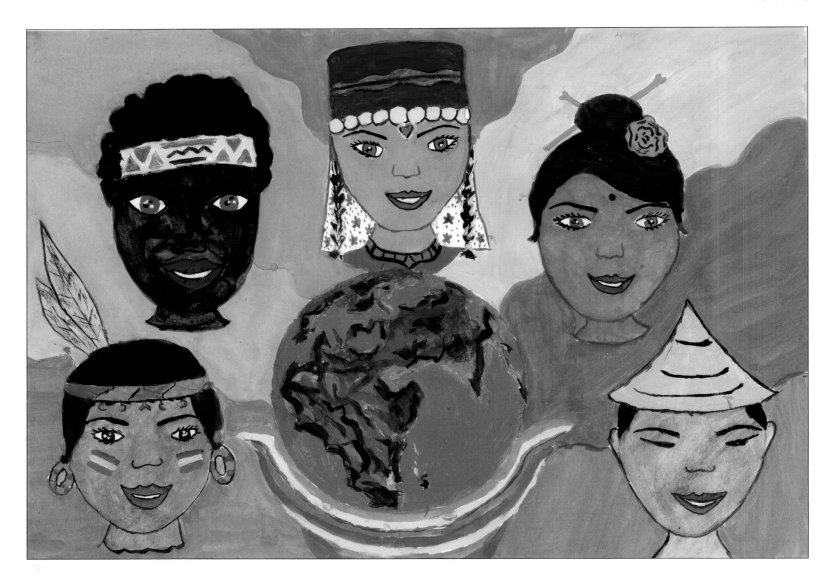

All the Children of the World
Sümeyye Telli
Age 12
Turkey
İtekin Primary School, Çankaya, Ankara
2005

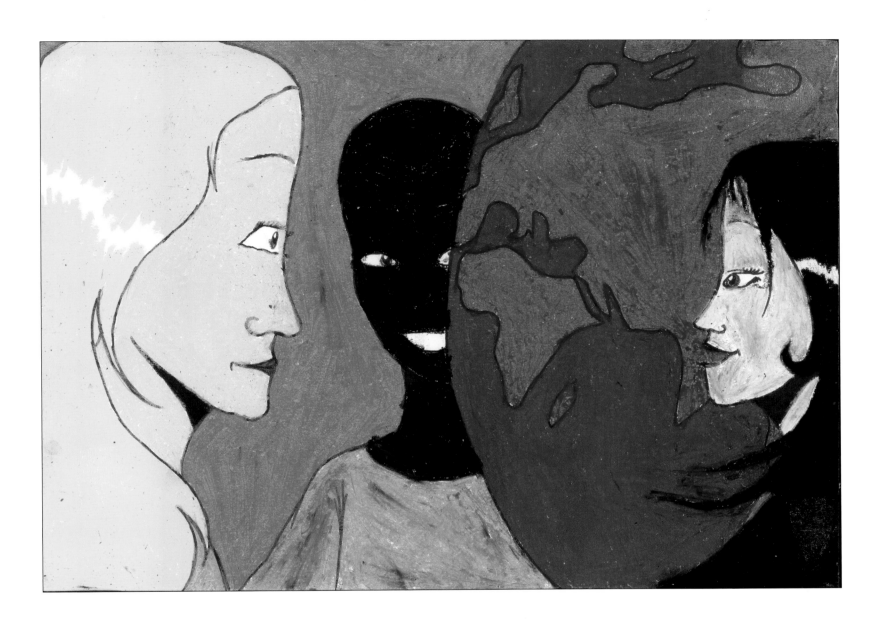

From East to West
Lauriina Pernu
Age 12
Finland
Kuvataidekoulu, Tuusula
2005

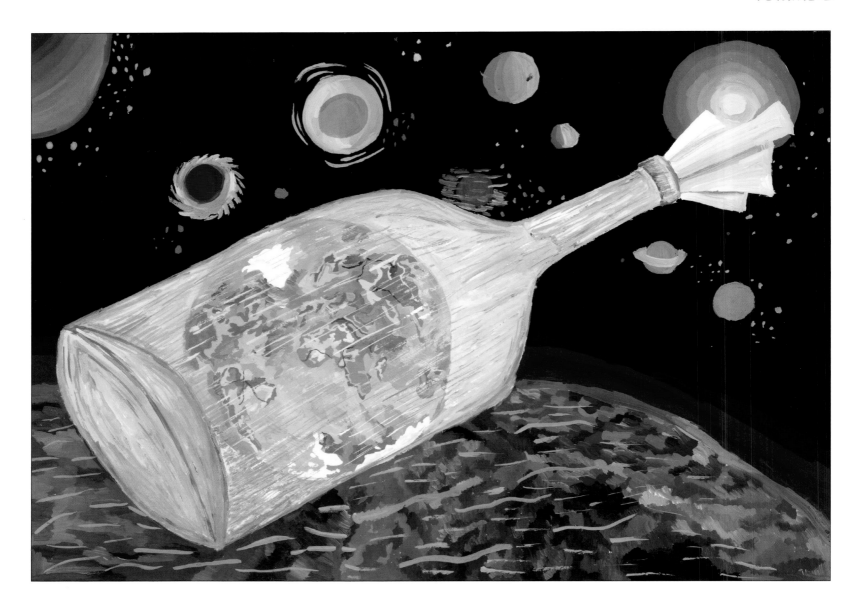

Help Our Earth (Diploma winner)
Evelin Demeter
Age 12
Romania
School of Arts, Târgu Mureş (Marosvásárhely)
2005

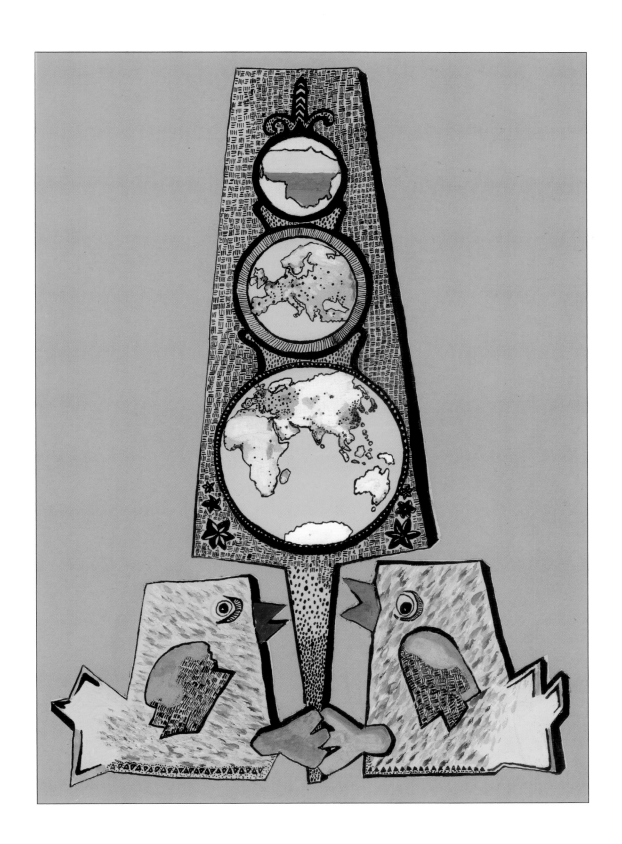

**Let's Spin the
Kindliness of the World**
Gabija Ražanskaitė
Age 12
Lithuania
"Aušros" Gymnasium, Kaunas
2005

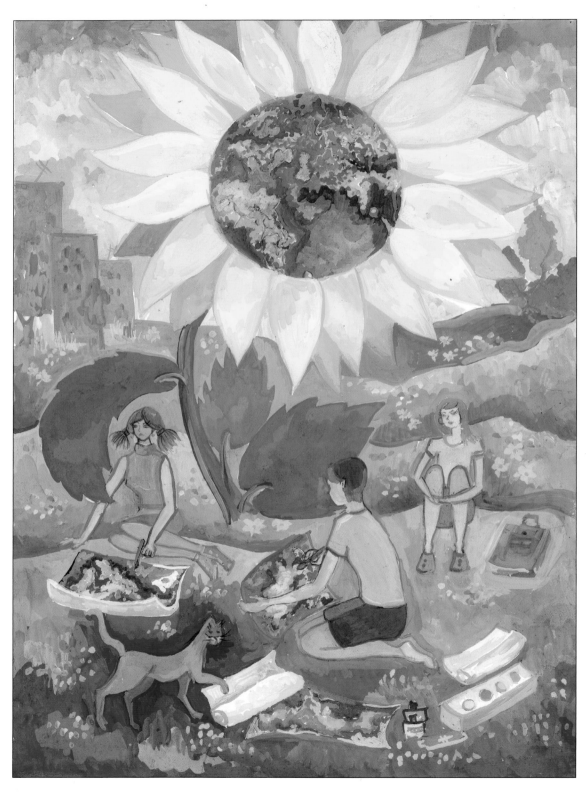

Planet without Colors
Is Not a Planet
Alina Zhuk
Age 12
Russian Federation
Children's Art School No.2, Penza
2005

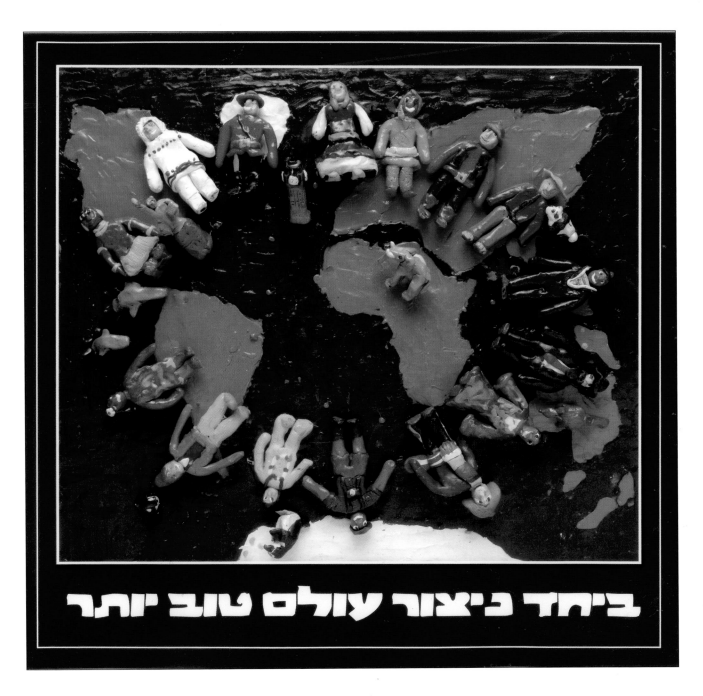

ביחד ניצור עולם טוב יותר

Together We Will Create a Better World
Yedidya Rozenburg
Age 12
Israel
Mateh Binyamin Junior School, Mizrach Binyamin
2005

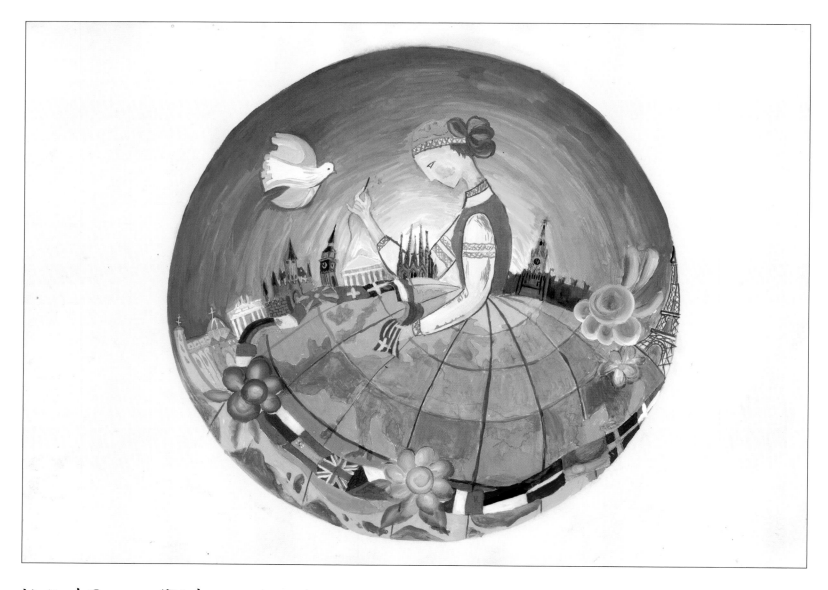

United Europe (Diploma winner)
Marcia Grieva
Age 12
Russian Federation
Children's Art School No. 4, Yekaterinburg
2005

Age 13

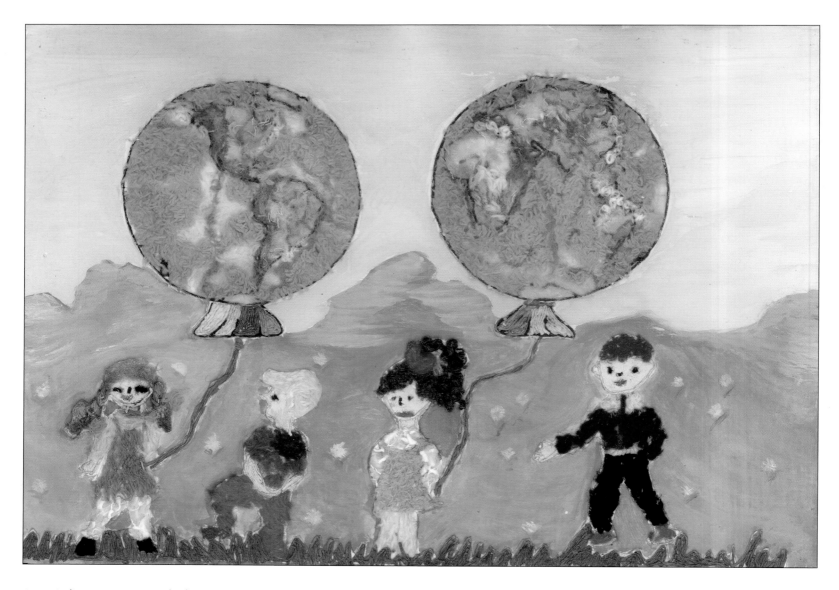

Be Bloom My Globe
Rimgaudas Zalupas
Age 13
Lithuania
Linkuvos Special School, Linkuva, Pakruojo
2007

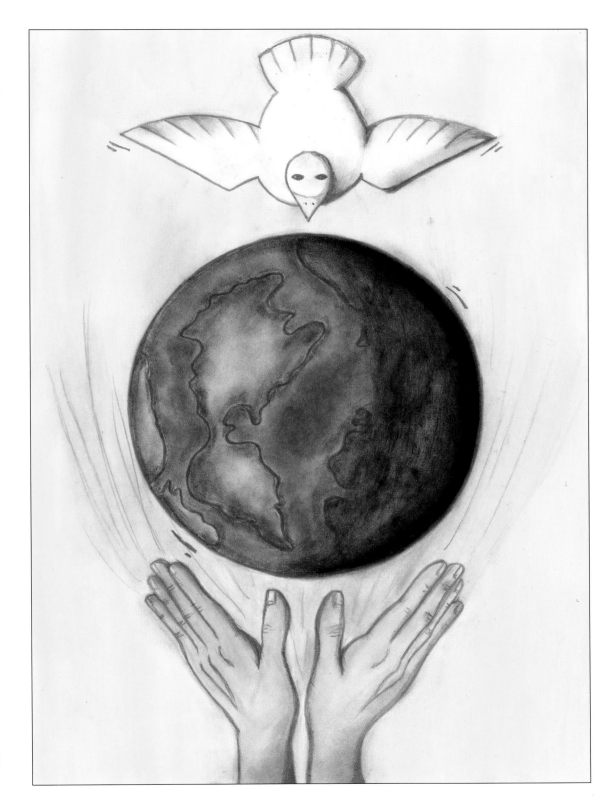

Dove of Peace
Siri Danielsen
Age 13
Norway
Ånstad Oppvekstsenter, Ånstad
2005

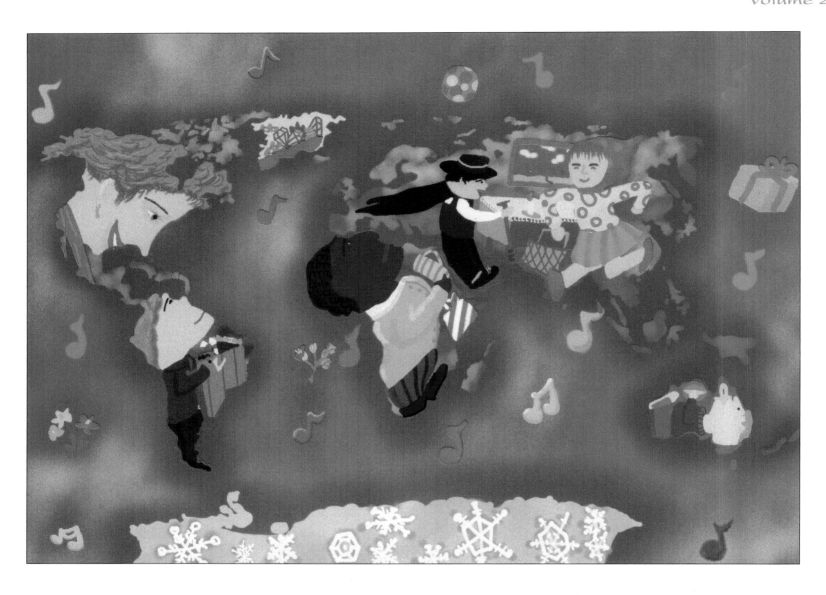

Happy World
Biaoyunke Zhang
Age 13
China
Lanling Primary School, Changzhou
2007

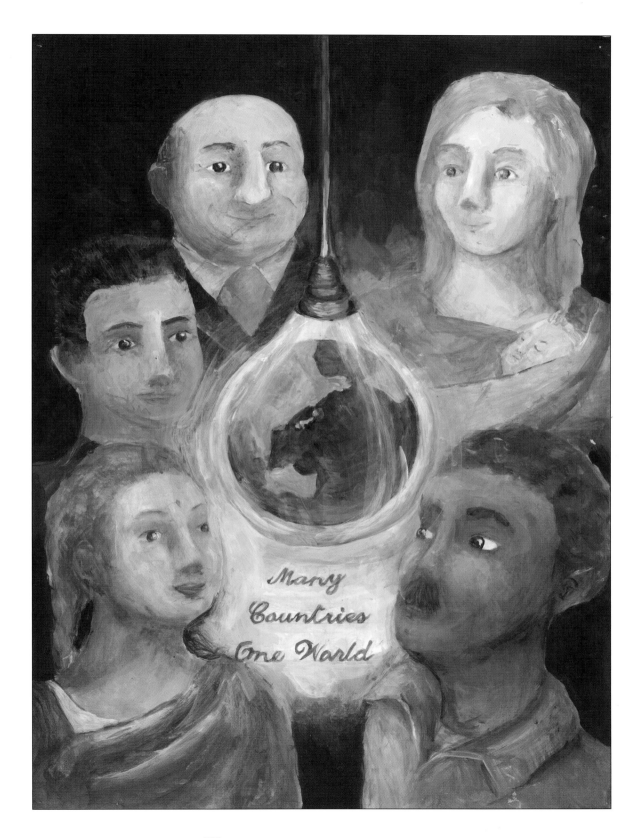

Light of the Earth,
Light of Hopes
Ami Kanno
Age 13
Japan
Nakada Secondary School,
Nakada
2007

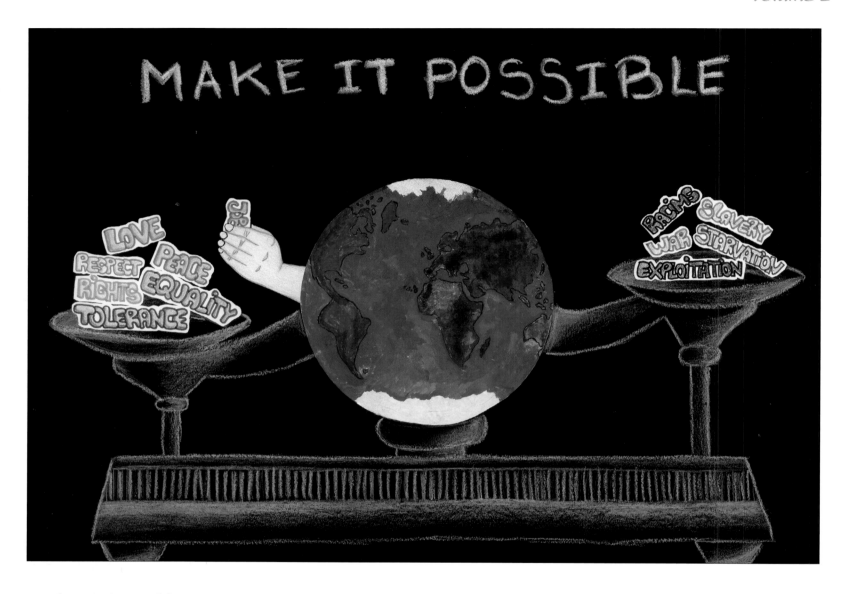

Make It Possible
Sandra Páez Ramos
Age 13
Spain
Meco, Madrid
2007

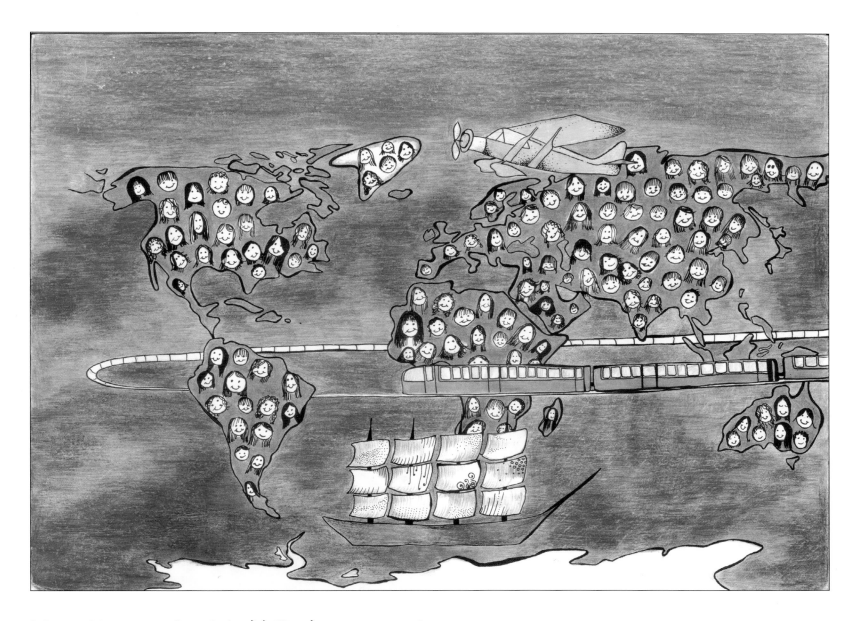

Many Nations, One World (Diploma winner)
Gintarė Kvietkutė
Age 13
Lithuania
Šilalė Art School, Šilalė
2005

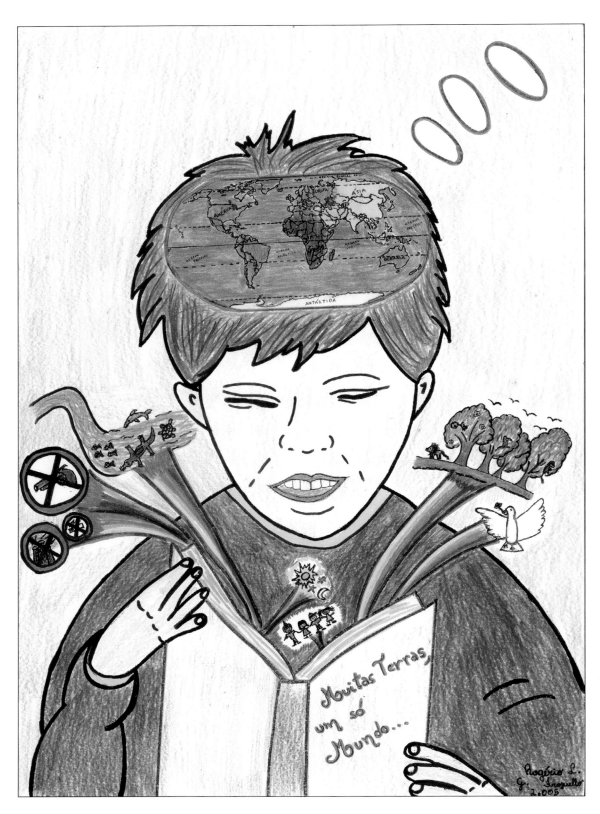

Many Nations,
One World
Rogerío Frojuello
Age 13
Brazil
Colégio São Sabas, São Paulo-SP
2005

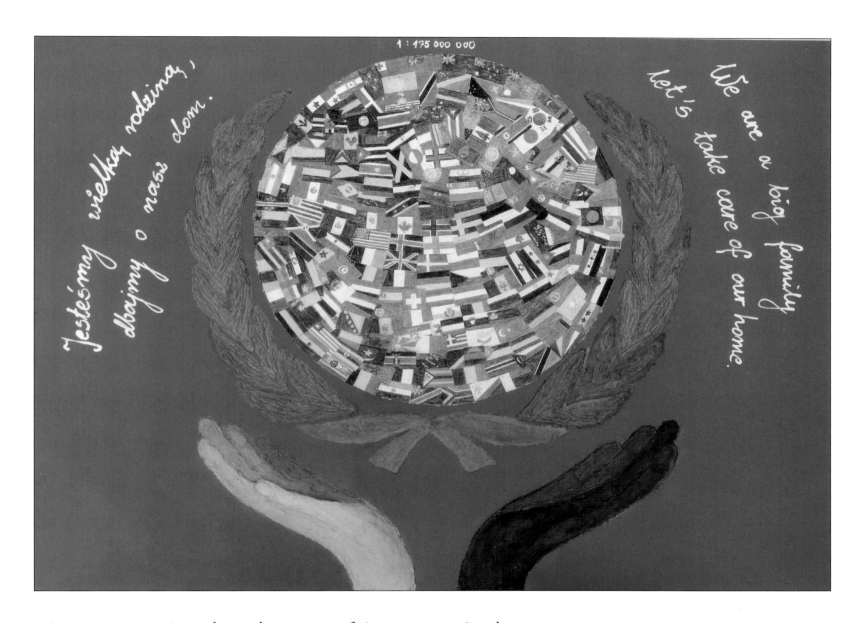

We Are Great Family, Take Care of Our Home (Diploma winner)
Alicja Ogorzelska
Age 13
Poland
Szkoła Podstawowa nr. 223, Warszawa
2005

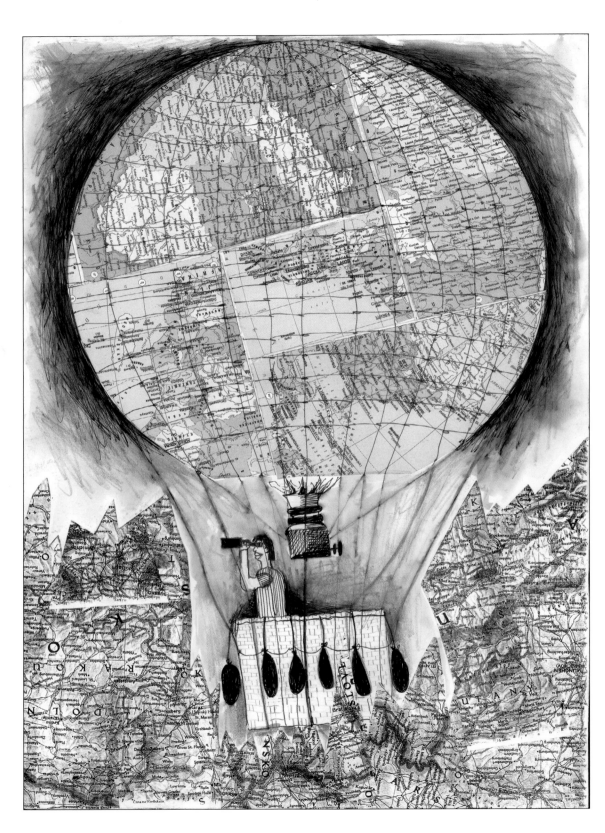

We Are Traveling around the World
Jakub Novotný
Age 13
Czech Republic
ZUŠ, Znojmo
2007

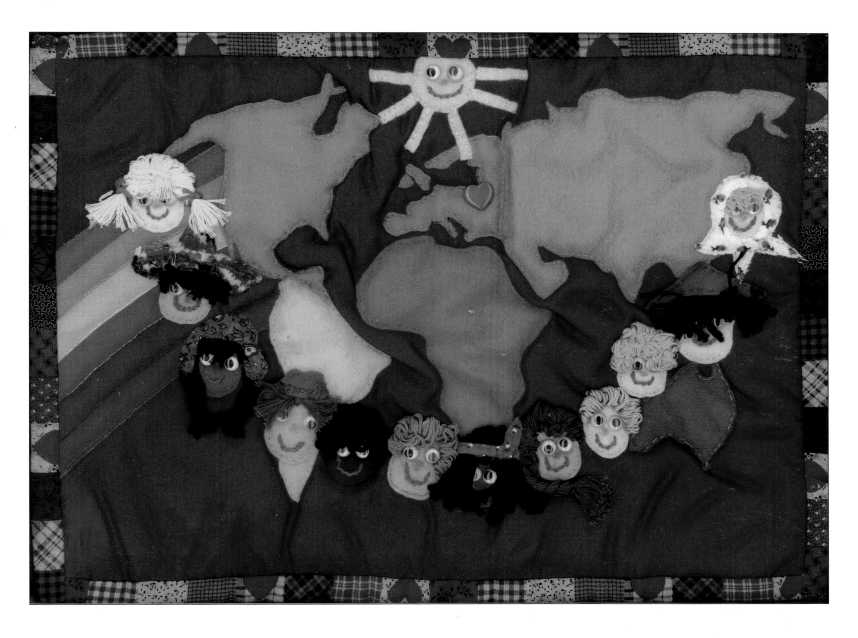

We Have Different Colors of Skin, but We Are All Children
Marta Londzin
Age 13
Poland
Szkoła Podstawowa Towarzystwa Ewangelickiego w Cieszyne, Cieszyn
2007

Age 14

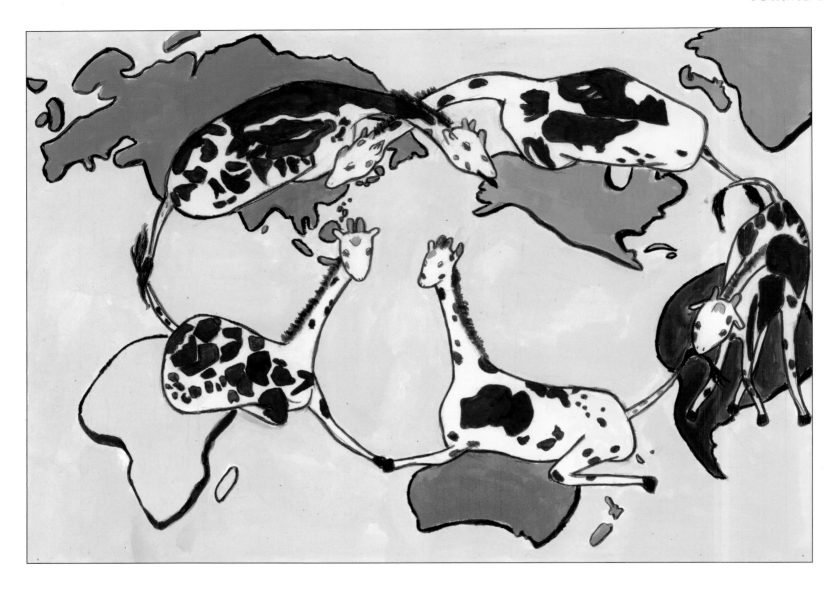

Giraffes with Country Shape Patterns Linking Five Continents
Chika Fujimura
Age 14
Japan
Nakada Secondary School, Nakada
2007

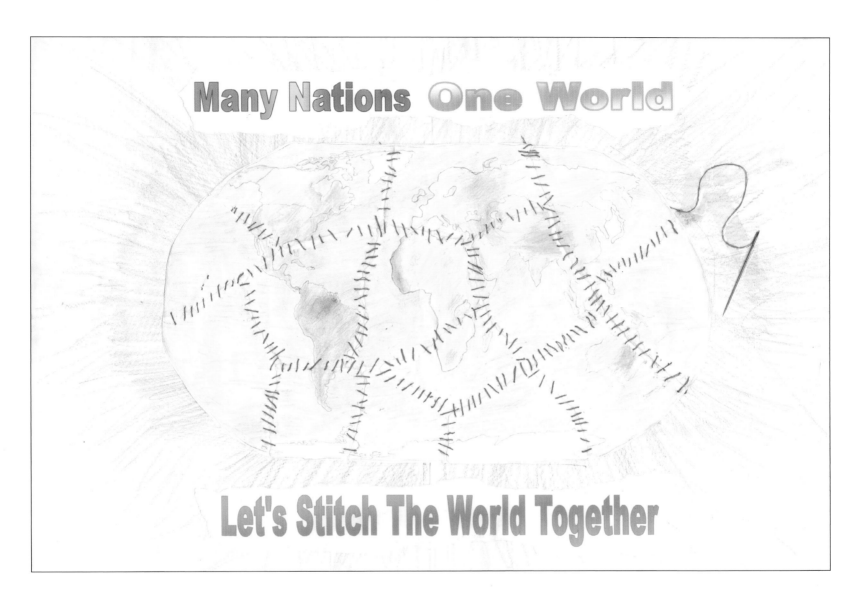

Let's Stitch the World Together
Bar Omer and Liora Haimov
Age 14
Israel
Idanim High School, Ramle
2005

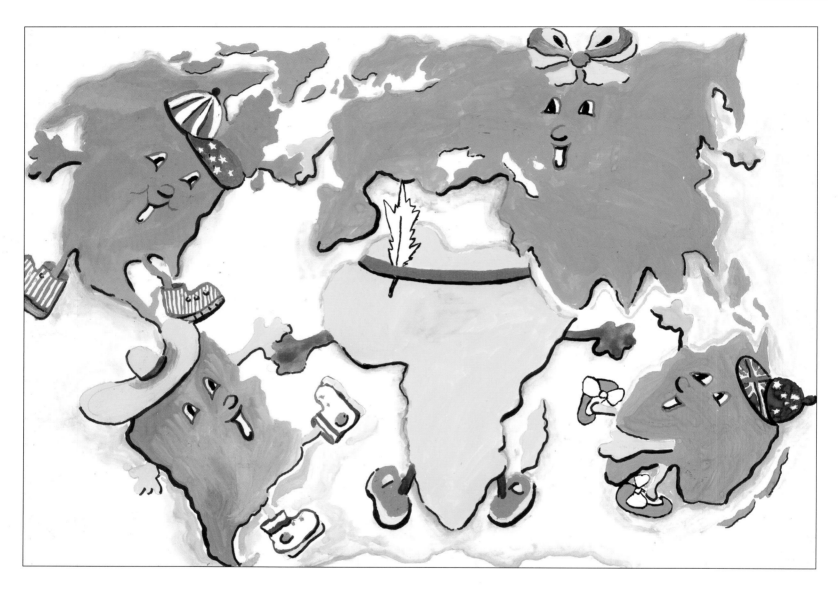

Merry Dancing
Svitlana Moskalenko
Age 14
Ukraine
Secondary School No. 2, Bashtanka
2007

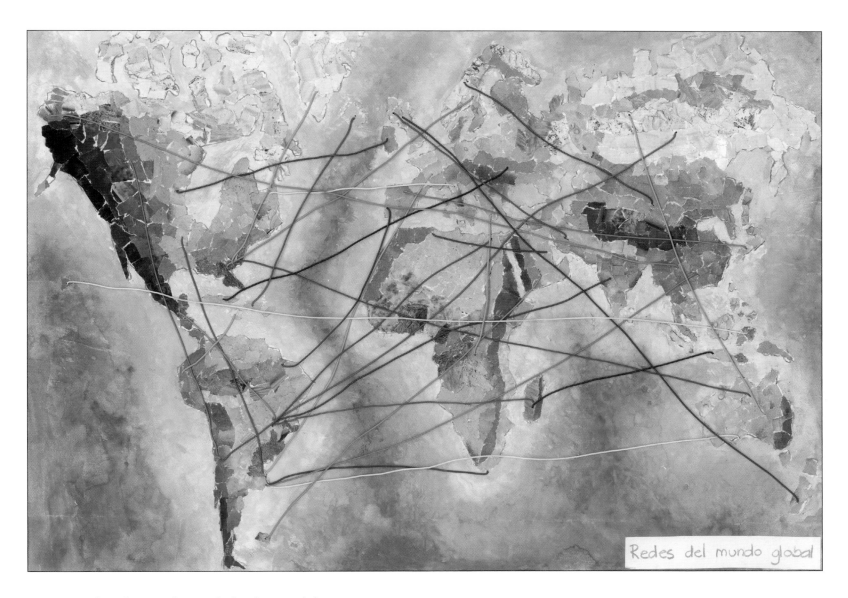

Networks from the Global World
Maria Guadalupe Gabancho
Age 14
Argentina
Hans Christian Andersen, Ciudad Autónoma de Buenos Aires
2005

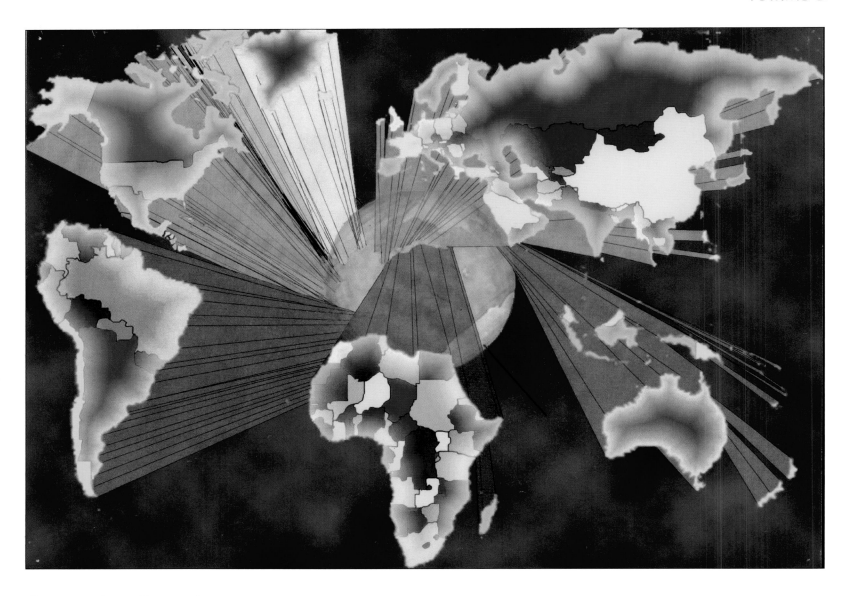

Surpassing Countries
Tamás Csikós
Age 14
Hungary
Leövey Klára High School, Budapest
2007

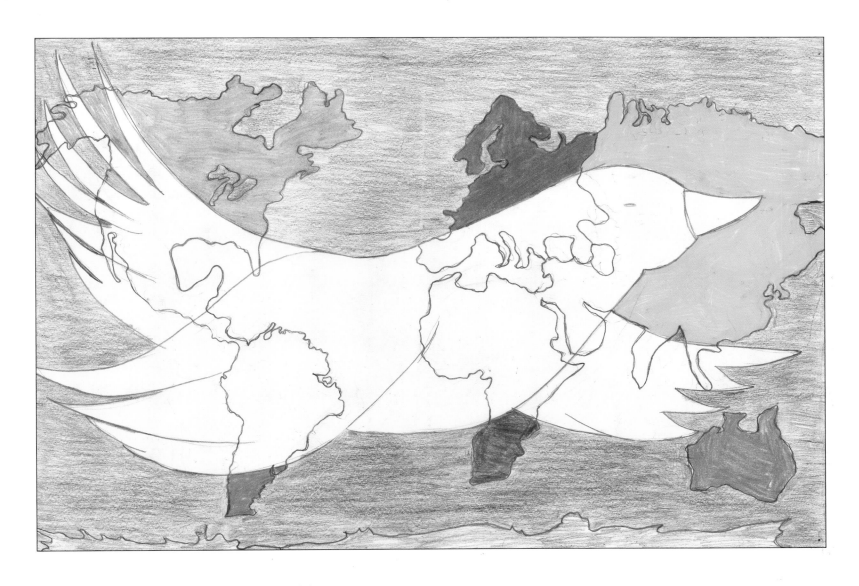

United Nations, a Peace World
Rodrigo Haubrich Medeiros
Age 14
Brazil
Rua São Teodósio, Inhoaiba/Camp Grande, RJ
2007

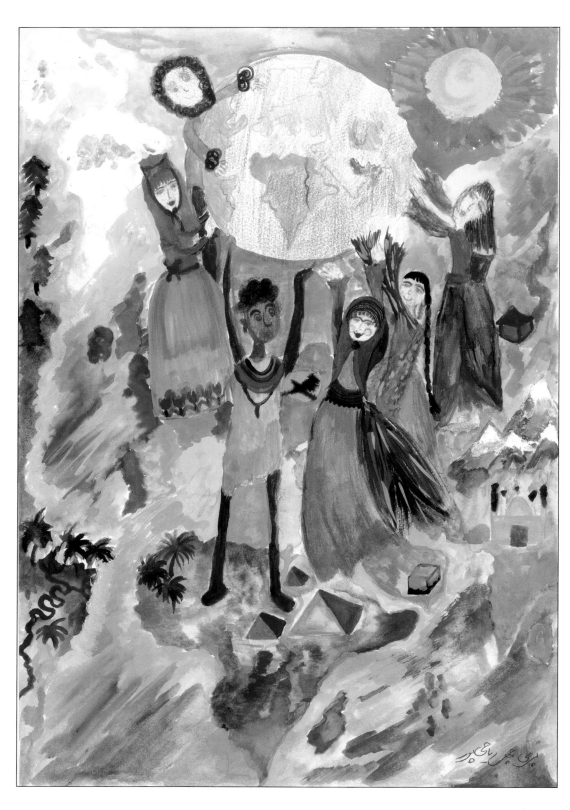

Untitled
Parichehr Riahipoor
Age 14
Iran
Omran, Ekbatan City, Tehran
2005

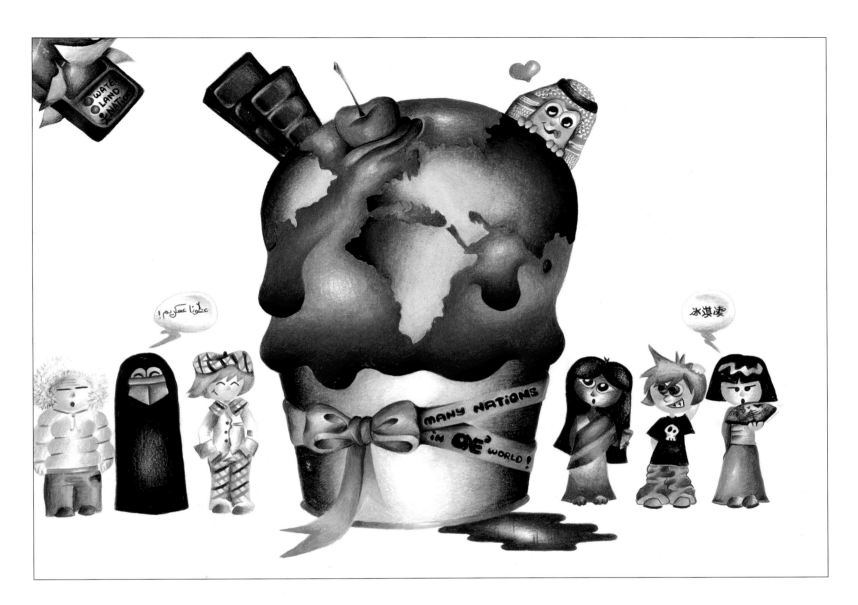

Untitled
Yasmin Ahmed Ali
Age 14
Qatar
2007

Age 15

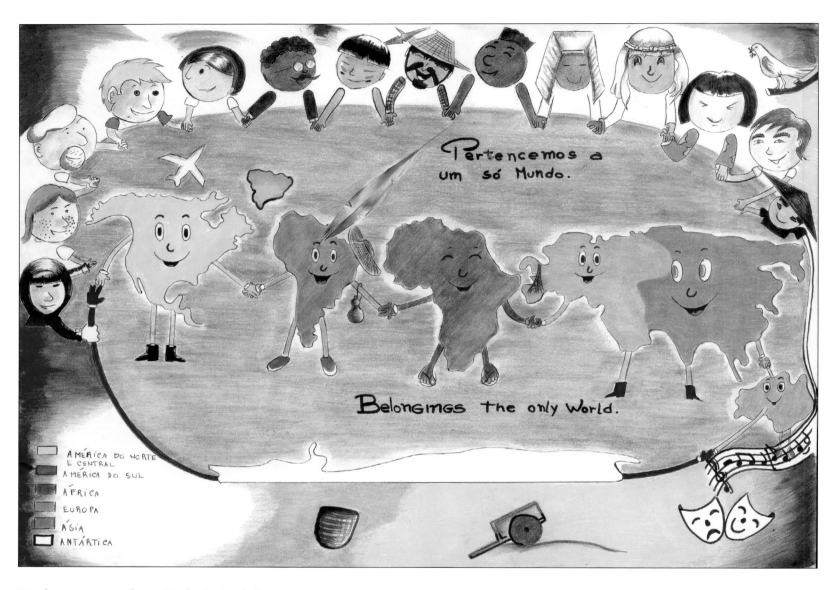

Belongings the Only World
Gildásio Souza Santos
Age 15
Brazil
Escola de Educação Básica e Profissional Desembargador
Pedro Ribeiro de Araújo Bittencout—"Fundação Bradesco," Irece, BA
2007

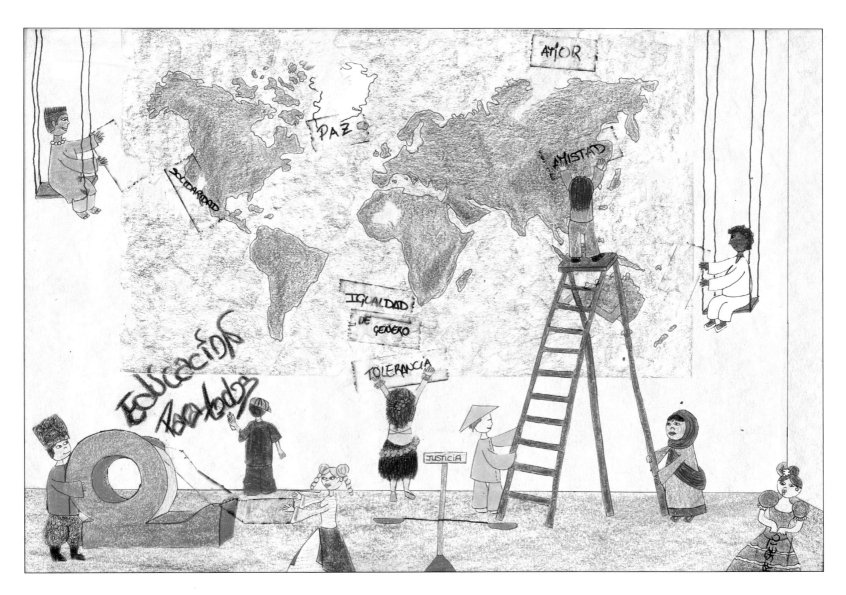

Fixing the World
Ana Medina Saldaña
Age 15
Spain
Meco, Madrid
2007

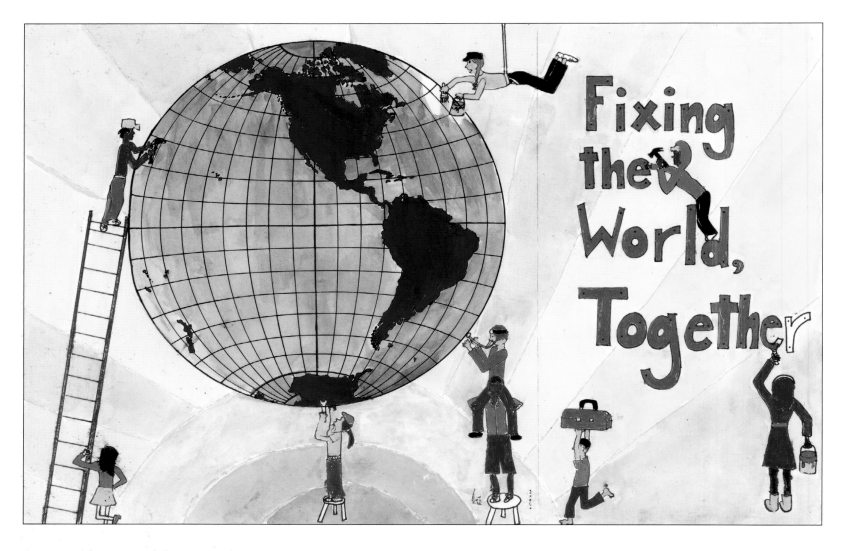

Fixing the World, Together
Malena Harrang
Age 15
United States
Forest Ridge School of the Sacred Heart, Bellevue, Washington
2007

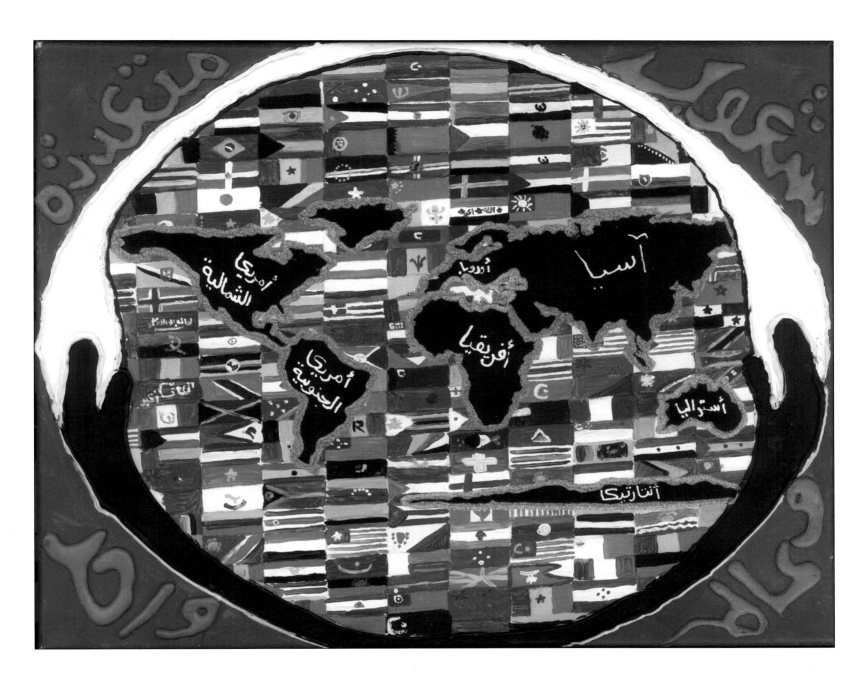

Many Nations, One World
Basma Ahmed Jabir
Age 15
Saudi Arabia
Dar Alfeker (Jaddah girls section) Jaddah
2007

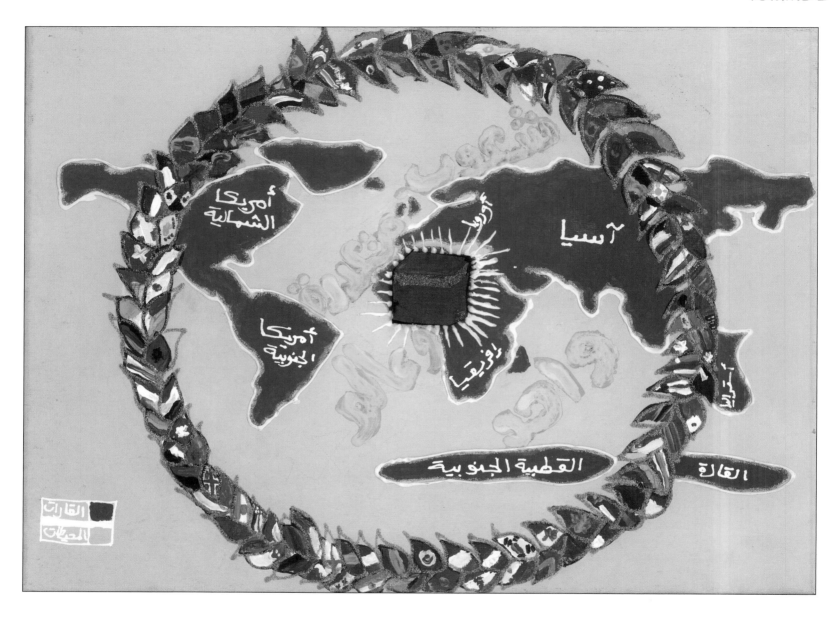

Many Naations, One World
Dana Jamal Al Omri
Age 15
Saudi Arabia
Dar Alfeker (Jaddah girls section) Jaddah
2007

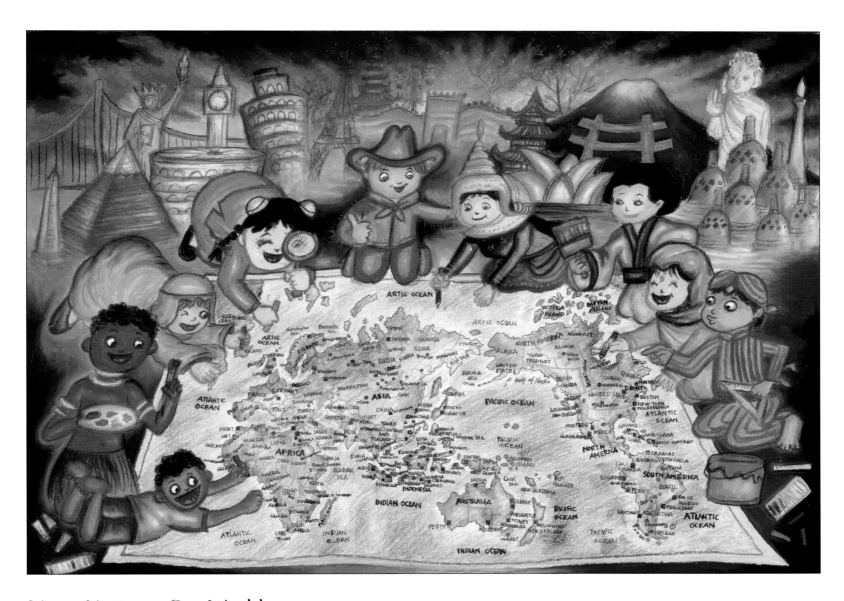

Many Nations, One World
Nicholas William
Age 15
Indonesia
SMA St. Bellarminus, Menteng, Jakarta Pusat
2005

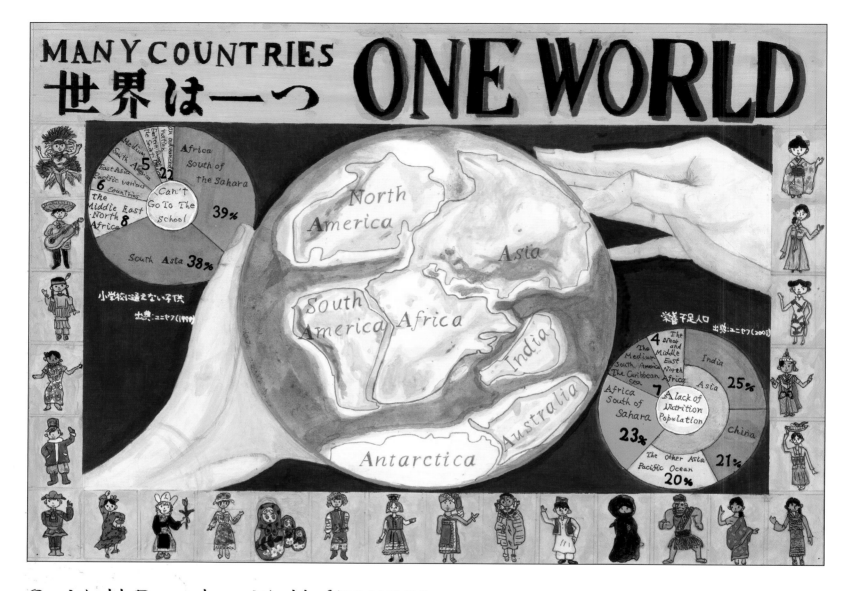

One World, Remember a World of PANGEA
Yukari Hoshi
Age 15
Japan
Itstsubashi Secondary School, Itstsubashi
2007

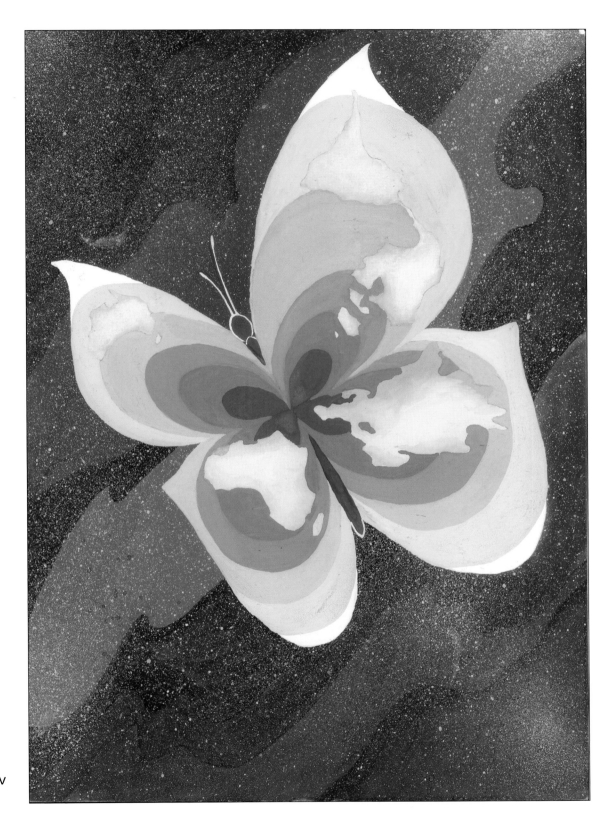

Space Butterfly
Kseniia Ivanova
Age 15
Ukraine
Palace of Creative Works
for Children and Juniors, Kharkiv
2007

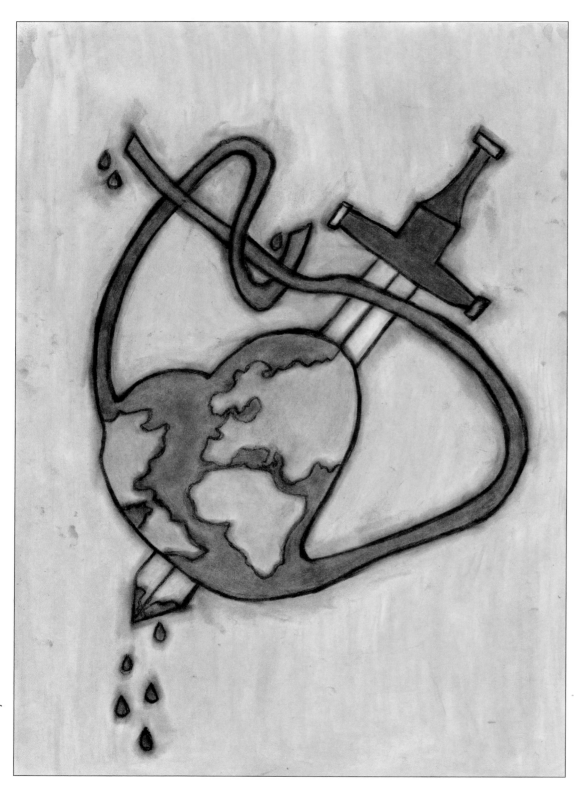

The World Can No Longer Manage the Pain
Rita Johansen
Age 15
Norway
Ibestad ungdomsskole, Ånstad
2005

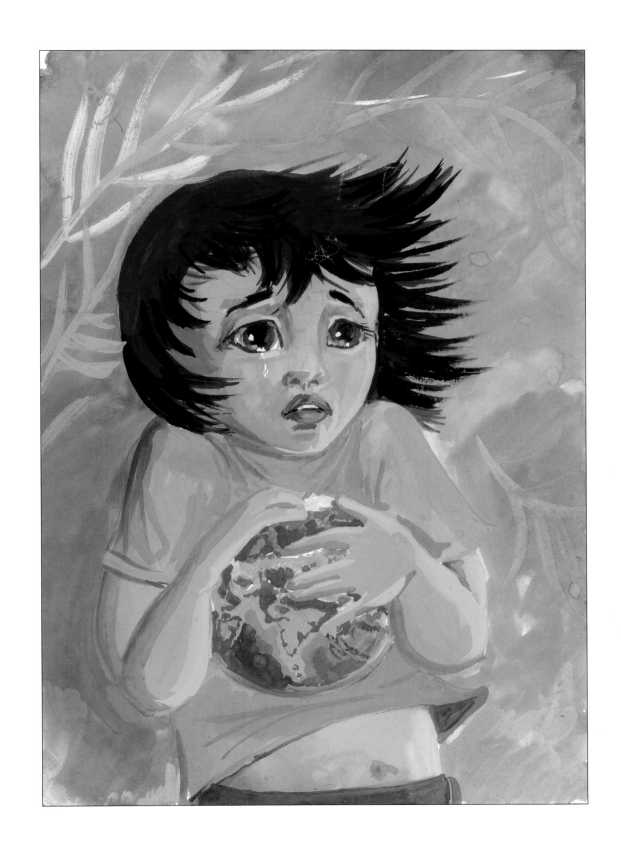

Tsunami — 2004
Polina Kosovskaya
Age 15
Russian Federation
"Water-Color" School, Mayna,
Respublika Khakasia
2005

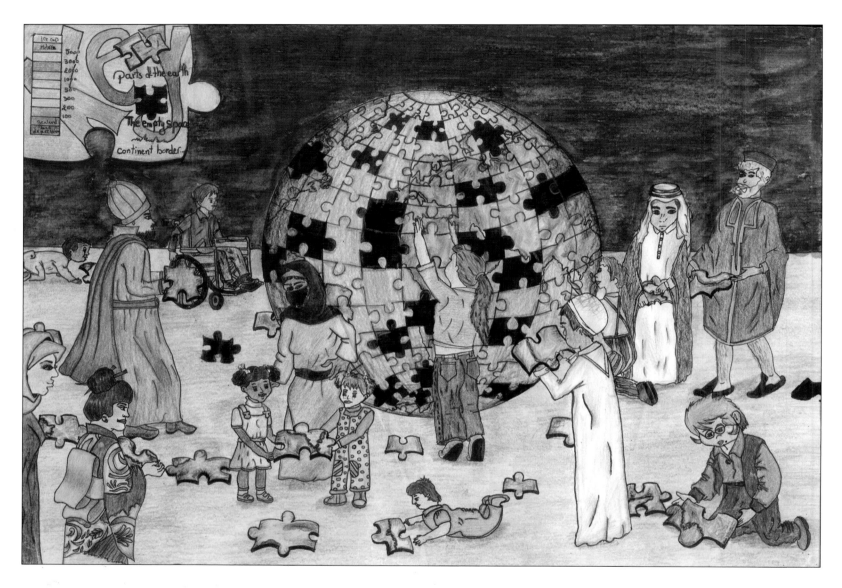

Untitled
Dura Mohammad
Age 15
Qatar
2007

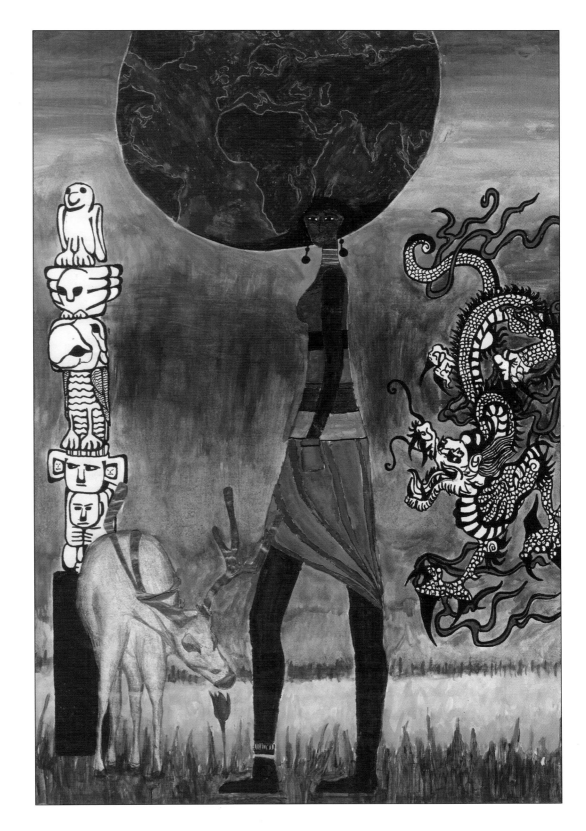

Untitled
Gitte Möller
Age 15
South Africa
Hoërskool Jan van Riebeeck,
Cape Town
2007

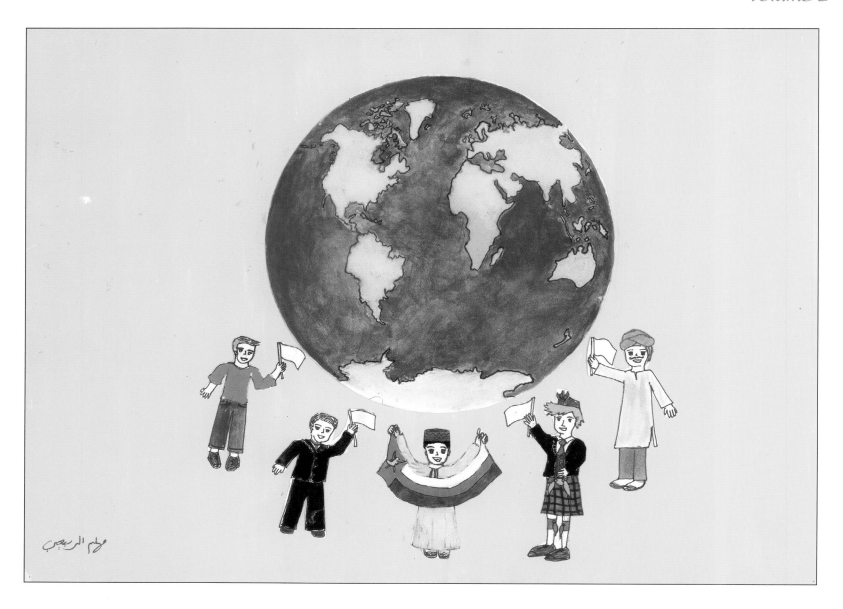

Untitled
Molhem Mohammad AlRoobaaee
Age 15
Oman
Oman Private School, Masqat
2007

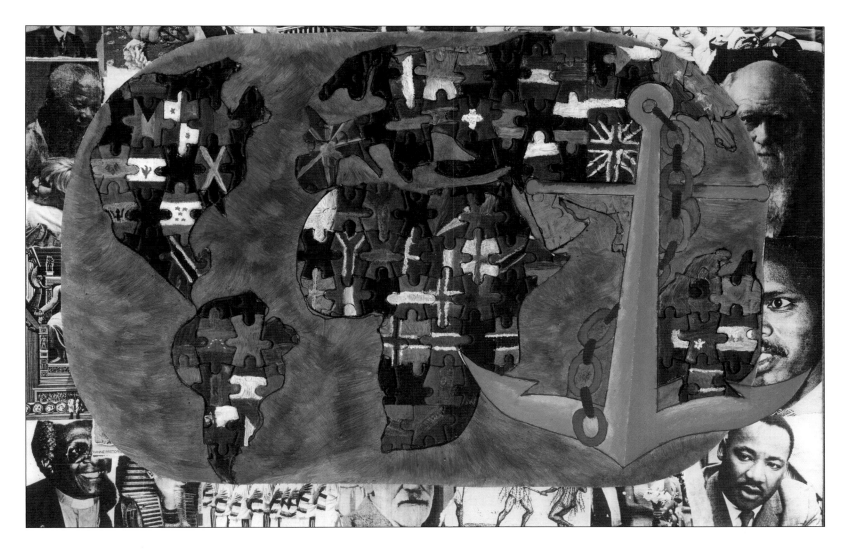

Untitled
Monique Rossouw
Age 15
South Africa
Hoërskool Jan van Riebeeck, Cape Town
2007

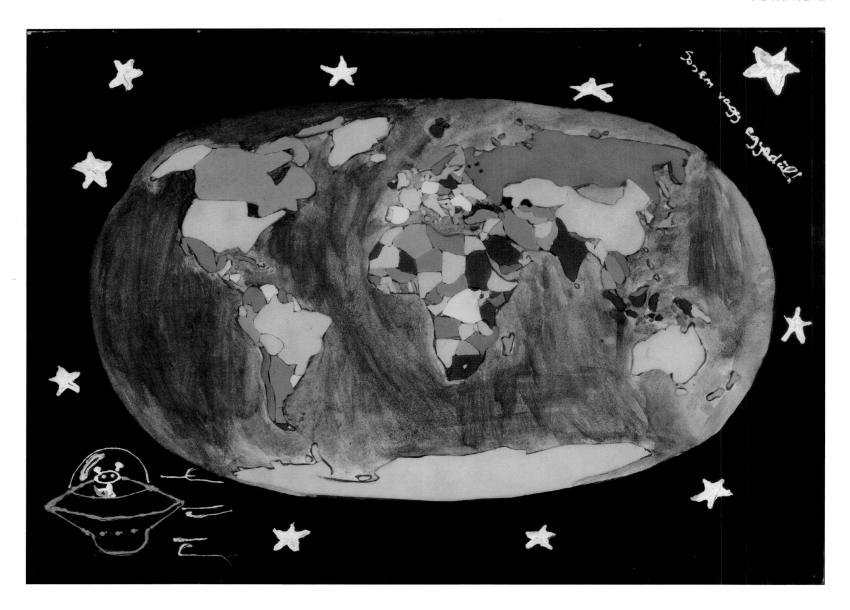

You Never Are Alone!
Emese Blaschek
Age 15
Hungary
Leövey Klára High School, Budapest
2007

Conversations with past participants

The editors contacted past participants in the Barbara Petchenik Children's World Map Competition and asked them to share their competition experiences.

Flag of Canada

Patricia Lan
Canada
2001
Save the Earth

Patricia, how did you hear about the competition, and what inspired you to enter?

My mother had discovered a contest poster at the local university and encouraged me to enter. My parents had great faith in my abilities. The 2001 catchphrase was "Save the Earth," so I thought of animals and habitats around the world. I loved drawing animals, so this was right up my alley. For the world map, I paid great attention to detail and proportion, and it became my proudest accomplishment since nothing was hand-traced.

It must have been a great feeling to be chosen as a Canadian finalist and then an international winner. What did you gain from your experience in 2001 and again in 2003?

I was surprised that I was a national and international finalist. I always tried my best in drawing contests but never expected to win, and whenever I did, it made the world seem a lot smaller. At 12 years old, I didn't realize the scope of the contest, what a big deal it was, until I won. What I learned was that even if you're unsure of how you'll measure up to others, sometimes you'll win if you try. I think this was the inspiration that my sister, Victoria, took to heart when she entered the 2005 and 2007 contests and succeeded in becoming a national finalist.

Flag of the Czech Republic

Lucie Mertova
Czech Republic
2007
The Sun and the Moon Are Shining to Our Earth

Lucie, what inspired you to participate in the Barbara Petchenik Children's World Map Competition?

I heard about the competition from my teacher, Ms. Cilová. I was inspired to participate by painting the picture, it was very interesting. [While painting] the map, I have learned many things. It was great fun to paint the sun and the moon.

Drawings by Riley Peake, courtesy of ESRI.

Anelia Jotova
Bulgaria
1999
Let's Clean the World

Flag of Bulgaria

Anelia, one of your maps is included in the first volume of *Children Map the World*. Explain how you got the idea for your map and what you learned while creating it?

I wanted to draw not only a picture but a message. Children know much more about the world than adults suppose. When I was 10, I was reading children's encyclopedias and I was admiring the beauties of the world. I knew that many of these natural miracles are destroyed or even lost forever because of man. The ecological theme was exciting to me and I decided to integrate it [into] my picture. "Let's clean the world" was my appeal.

Anna Parvanova
Bulgaria
2007
All Together for a Common World

Anna, your drawing "All Together for a Common World" has been included in the second volume of *Children Map the World*. Please describe your experience of the Barbara Petchenik Children's World Map Competition.

My drawing [won] first place. Your competition was a challenge for me. I saw a lot of atlases with my drawing teacher, and I chose to draw the earth [in a way in which only] some

countries may be seen. I put in my drawing many children of different nations, because according to me, [it doesn't] matter which country we are from, the most important thing is to love the earth—Mother Nature—and to take care of it. That's why I called my drawing "All Together for a Common World."

While I was drawing, it was very interesting to me how different maps and atlases are done. I learned which symbols are used for marking the streams, the poles, [and other things]. With my drawing, I would like to tell adults that children will unite the world and we will make it better, [and] that we would like them to help us.

A biographical note

Barbara Bartz Petchenik

Barbara Bartz Petchenik (1939-1992) was a pioneer in the world of cartography. From 1965 to 1987, she conducted research and wrote more than a dozen articles and reports about a topic that was of considerable interest to her throughout her life: maps and atlases for children. For her contribution to this field, the International Cartographic Association (ICA) named the Barbara Petchenik Children's World Map Competition in her honor in 1993.

Barbara Bartz was born on August 17, 1939, in rural northern Wisconsin. Her family was well established and highly respected in the community. She grew up in a secure and nurturing environment that gave her the necessary self-confidence to achieve. By the time she was in high school, "the Bartz girls" (Barbara and her seven cousins—there were very few boys in the family) were recognized as achievers and leaders, both academically and socially. Though, in Barbara's words, her achievement was "more the former than the latter," as she "was never a prom queen."

In 1961, Barbara obtained a bachelor of science degree from the University of Wisconsin-Milwaukee with a major in chemistry and a minor in English. She spent the following year working at the university as a geography instructor, and in September 1961 served as the founding "map librarian" of the university's New Map and Air Photo Library. In 1962, she was awarded a National Defense Education Act Fellowship and entered the graduate program at the university. She intended to obtain a PhD in physical geography, concentrating on soils, with the ultimate goal of teaching at the university level. However, after earning her master's degree in 1964, she became a cartographic editor with the Field Enterprises Educational Corporation in Chicago. During her time there, she designed, conducted, and analyzed the research needed to produce maps and other material for the nine-to-fourteen-year-old audience of the *World Book Encyclopedia*.

In 1970, after earning her PhD, Barbara accepted a five-year position at the Newberry Library as cartographic editor. Here, she planned, designed, and produced the *Atlas of Early American History* with editor-in-chief Lester Cappon and a staff of historians. From 1975 until her death in 1992, she served as the senior sales representative of cartographic services for the R. R. Donnelly and Sons Company. In her writing, she continued to pursue her interest in education.

Barbara wrote several articles and reports about maps for children from 1970 to 1987. Her work explored fundamental aspects of atlases for children by informally considering particular atlases. She thoughtfully observed

> *Maps are mostly far too complex to "learn" at one or even many glances. The only way to try to make sure that children leave school with some idea of the relative shapes and sizes and arrangements of labeled earth areas and features is to provide opportunities for them to see and use these images (maps) on a highly repetitive and (I happen to prefer) structured basis.*[1]

Barbara did much of her research about maps for children during her tenure with Field Enterprises. During the process of designing maps for the *World Book Encyclopedia*, she collected empirical evidence on which types of maps children preferred and could most easily understand, and used this evidence as a basis for her map design. She interviewed a thousand elementary school children and invited them to interpret alternative styles of small-scale maps. From this work, she identified difficulties children had with the interpretation of scale, coordinates, symbology, and typography. Her research showed that children valued clarity in cartography and liked less-cluttered maps with more clear spaces. She noted that although teachers claimed map use was an important skill, children were rarely taught how maps worked. Above all, she recognized that children are a large and important group of map consumers, that they do not approach maps in the same way as adults, and that their distinct perspectives should be taken into account in the process of map design. The articles and research publications in the bibliography that follows provide opportunities to learn more about her philosophy on cartography, especially as it relates to children.

Barbara was active in many professional organizations, including the American Congress on Surveying and Mapping's (ACSM) American Cartographic Association, the Association of American Geographers, the Society of Automotive Engineers, and the International Cartographic Association. She also served as a member of the editorial board of *The American Cartographer*. Through her efforts, the ACSM Map Design Competition began giving awards for student-designed maps. She served as a member of the U.S. National Committee to the International Cartographic Association. She participated in several ICA activities over the years, and in 1991 at the General Assembly in Bournemouth, England, she was the first woman to be elected vice president of the ICA.

Over the nearly twenty years that I knew Barbara, I was always impressed by her intelligence and good humor. We enjoyed a lively camaraderie over the years. Her presence, scholarly contributions, and spirited intellectual discussions have been and will continue to be missed. The Barbara Petchenik Children's World Map Competition is a fitting way of keeping her alive in our memories.

Alberta Auringer Wood (with assistance from Patrick Wiegand)

1 Fundamental considerations about atlases for children. 1987. *Cartographica* 24:16-23.

Works by Barbara Bartz Petchenik about children and maps

Cartography for children: A research approach. 1971. *La Revue de Geographie de Montreal* 25: 407–10.

Designing maps for children. 1971. *Cartographica* monograph 2:35–40. Presented at the symposium on the Influence of the Map User on Map Design at Queen's University.

Evaluation of two-color political maps in *World Book* (Chad, Singapore, Sierra Leone, Formosa, Nigeria). 1967. Research report for Field Enterprises Educational Corporation, Chicago, 43.

Experimental use of the search task in an analysis of type legibility in cartography. 1970. *Journal of Typographic Research* 4 (Spring): 102–08. Reprinted in *The Cartographic Journal* 7 (2): 103–12.

Facts or values: Methodological issues in research for educational mapping. 1984. Paper presented at the Twelfth Conference of the International Cartographic Association, Perth, Australia, August 6–13. *Technical Papers* 1: 788–804. Reprinted as essay 2 in Value and values in cartography *Cartographica* 22 (3): 20–42.

Fundamental considerations about atlases for children. 1987. *Cartographica* monograph 36, 24 (1): 16–23.

Map design for children. 1965. Research report for Field Enterprises Educational Corporation, Chicago, 224.

Map type: Form and function. 1966. Research report for Field Enterprises Educational Corporation, Chicago, 145.

Maps and children. 1971. Letter in *Journal of Geography* 71 (2): 68.

Maps in the classroom. 1970. *Journal of Geography* 69 (January): 18–24. Reprinted in *Social science and geographic education: A reader*. 1971. John M. Ball, John E. Steinbrink, Joseph P. Stoltman, eds. New York: John Wiley and Sons, Inc.

Nature of research in education. 1972. *Journal of Geography* 71 (4): 215–32.

Review of *Junior atlas of Alberta* by J. C. Muller and L. J. Wonders. 1981. *The American Cartographer* 8 (1): 83–5.

Review of *Junior atlas of Alberta teachers manual* by W. C. Wonders. 1981. *The American Cartographer* 8 (1): 83–5.

Search: An approach to cartographic type legibility. 1969. *Journal of Typographic Research* 3 (4): 387–97.

Type variation and the problem of cartographic type legibility. Part one: Cartographic typography as a medium for communication; the cartographic view of legibility. 1969. *Journal of Typographic Research* 3 (2): 127–44.

What about Illinois? Or, children and a reference map. 1967. Research report for Field Enterprises Educational Corporation, Chicago, 71.

Works about Barbara Bartz Petchenik

Krejcie, Valerie Wulf. 1990. Barbara Petchenik. *Progress and Perspectives: Affirmative Action in Surveying and Mapping* (September–October): 3.

Krejcie, Valerie Wulf, Leona Sorenson, Richard E. Dahlberg, and Joel L. Morrison. 1992. Barbara Bartz Petchenik: An appreciation. *ACSM Bulletin* 139 (September–October): 24.

Morrison, Joel L. 1992. Barbara Bartz Petchenik: In remembrance. *Cartographica* 29 (2): 60–1.

Robinson, Arthur H. 1994. B. B. Petchenik (1939–1992). *Imago Mundi* 46: 174–5.

Rundstrom, Robert A. 1992. Barbara Bartz Petchenik: A personal appreciation. *Cartographica* 29 (2): 60–1.

Taylor, D. R. Fraser. 1992. Barbara Bartz Petchenik: In remembrance. *ICA Newsletter* no. 2: 7. Reprinted in *The Cartographic Journal* 29 (2): 160.

Resources

The Barbara Petchenik Children's World Map Competition is a biannual map design competition for children ages fifteen and younger hosted by the International Cartographic Association (ICA). Each submission should graphically represent the theme of that year's competition. For more information on the ICA, the competition, and where to access examples from past competitions, please see the following Web sites.

The International Cartographic Association is the world authoritative body on cartography and organizer of the Barbara Petchenik Children's World Map Competition: www.icaci.org.

The ICA Commission for Cartography and Children provides consultative support on rules and judging of the competition. Rules and guidelines for the competition can be found on the commission's Web site: http://lazarus.elte.hu/ccc/ccc.htm.

Carleton University Library in Ottawa, Canada, archives submissions from past international competition winners and makes them available for viewing: http://children.library.carleton.ca/.

ESRI Press publishes the *Children Map the World* series. Information on how to purchase books from this series, and related materials are posted on the series Web site: www.esri.com/children2.

Index by participant country of origin

Index

Participating country

Related titles from ESRI Press

Children Map the World: Selections from the Barbara Petchenik Children's World Map Competition

ISBN: 9781589481251

This vibrant collection of children's work from the Barbara Petchenik Children's World Map Competition presents a retrospective selection of 100 maps submitted over the first decade of the competition. *Children Map the World* includes award-winning entries, runners-up, and additional maps that reflect core values in surprisingly subtle and complex expressions. The messages embedded in these maps and the vulnerability of these children's creations make them not only accessible but inspirational.

Thinking Spatially Using GIS: Our World GIS Education, Level 1

ISBN: 9781589481848

Early exposure to geography, spatial thinking, and geographic information system (GIS) technology helps students learn more about the world around them. With this first volume in the Our World GIS Education book series, teachers are provided geographic tools—maps, geographic data, and GIS—to teach young students a basic understanding of spatial concepts, pattern recognition, and map trends analysis. Students improve and reinforce their basic map-reading skills and continue to sharpen those skills as the lessons prompt them to analyze and think critically about the data. In addition, one student workbook is provided containing all of the student exercises and handouts that correspond with the instructor text.

Also available: *Mapping Our World Using GIS: Our World GIS Education, Level 2*
ISBN: 9781589481817

Community Geography: GIS in Action

ISBN: 9781589480230

Community Geography is designed to inspire students and citizens to make a difference in their communities using GIS technology. The book includes seven case studies that describe innovative community projects in endeavors such as working with a local police department to map crime, analyzing landfill hazards, tracking river water quality, and taking inventory of area trees. Step-by-step exercises, guidelines, and practical tips for taking on similar projects in readers' own communities are included.

Also available: *Community Geography: GIS in Action Teacher's Guide*
ISBN: 9781589480230

Designing Better Maps: A Guide for GIS Users

ISBN: 9781589480896

This beautifully illustrated reference guide breaks down the myriad decisions regarding color, font, and symbology that must be made to create maps that effectively communicate the intended message of the mapmaker. *Designing Better Maps: A Guide for GIS Users* demystifies the basics of good cartography, walking readers through layout design, scales, north arrows, projections, color selection, font choices, and symbol placement. Recognizing the need for integration with other publishing and design programs, the text also covers various export options, all of which lead to the creation of publication-worthy maps. *Designing Better Maps* includes an appendix describing the author's popular ColorBrewer application, an online color selection tool.

ESRI Press publishes books about the science, application, and technology of GIS. Ask for these titles at your local bookstore or order by calling 1-800-447-9778. You can also read book descriptions, read reviews, and shop online at www.esri.com/esripress. Outside the United States, contact your local ESRI distributor.